LATIN AMERICAN ARTS & CULTURES

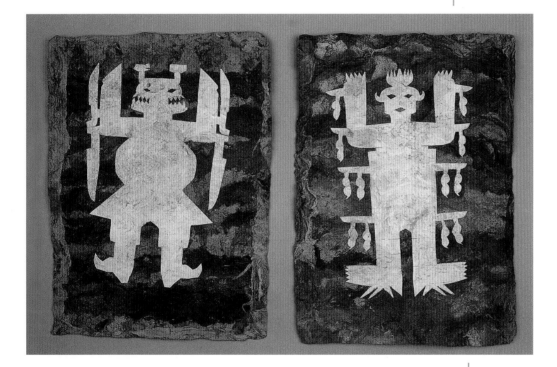

Otomí, Spirit Cutouts

Otomí people use paper cutouts in ceremonies to bring rain, cure illness, and assure good luck and prosperity. The paper dolls represent the life force of the ancient spirits who control their world. (For more on ancient myths and legends, see chapter two.)

San Pablito, Puebla, Mexico, 1970. Amate bark paper, 8 1/2" x 11 8 1/2" (21.6 x 29.2 cm). Collection of the author. Photo: Davis Art Slides.

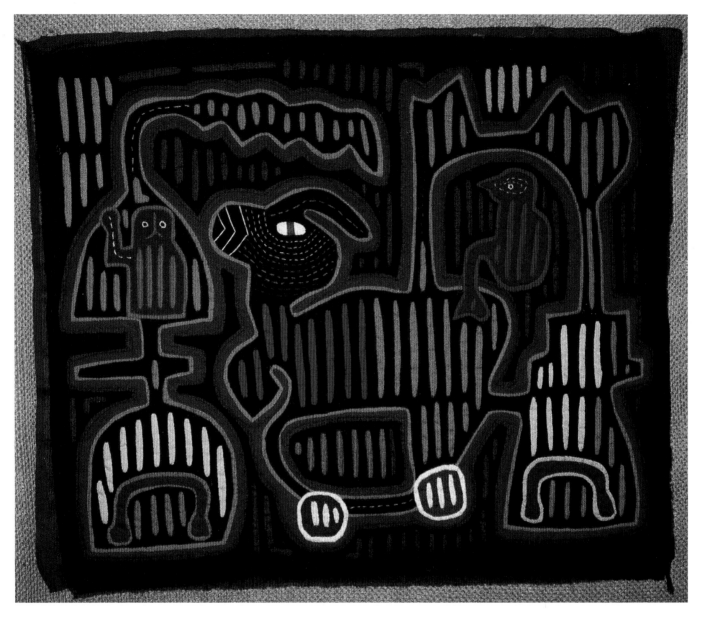

Kuna, Mola

Kuna women from the San Blas Islands often decorate their blouses with *molas*.
Molas are made by sewing panels of colored cotton on top of one another, then cutting
away to reveal some of the fabric of the layer below. The overall shape of the main
mola design is often borrowed from nature or from Kuna mythology. Sometimes it is
inspired by dreams or fantasies. (For more on molas, see pages 98 and 99.)

San Blas Islands, Panama/Colombia, 20th century. Sewn and embroidered cotton, 17" x 14" (43 x 35.6 cm).
Collection of the author. Photo: Dorothy Chaplik.

LATIN AMERICAN ARTS & CULTURES

Dorothy Chaplik

Davis Publications, Inc.
Worcester, Massachusetts

Acknowledgments

Many people have contributed to the preparation of this book. Professor Joel Palka and James Westerman, both pre-Columbian scholars, read sections of the manuscript and made important suggestions. Several artists, photographers, and collectors graciously permitted reproduction of their works. I am especially grateful to my friend Lucrecia Bernal, who painstakingly read the entire manuscript, offering valuable guidance and sharing her rich background in art.

—Dorothy Chaplik

Copyright 2001
Davis Publications, Inc.
Worcester, Massachusetts, U.S.A.

Publisher: Wyatt Wade
Editorial Director: Helen Ronan
Developmental Editor: Nancy Wood Bedau
Production Editor: Carol Harley
Educational Consultant: Kaye Passmore
Copyeditor: Janet Stone
Proofreader: Mary Ellen Wilson
Manufacturing Coordinator: Georgiana Rock
Design and Layout: Karen Durlach
Icon and Sidebar Illustrations: Paul Weiner
Timeline Illustration: Nancy Wood Bedau
Design Concepts: Greta Sibley, Norman Sibley

Library of Congress Catalog Card Number: 00-109708
ISBN: 0-87192-547-8

10 9 8 7 6 5 4 3 2 1
Printed in China

Front Cover:

Inca Sun Festival in Peru

Still celebrated today is the ancient legend of the son of the sun god, who gave the Inca the divine right to rule. During Inca times, splendid ceremonies honoring the god took place at the Coricancha, the great Temple of the Sun in Cuzco. After the Spanish conquest, the temple was torn down and replaced by the Church of Santo Domingo, but the sun god is still remembered with colorful pageants and festivals that affirm Inca greatness.

Photo taken at Inti Raymi, the Inca Sun Festival held annually on June 24th at the Sacsahuamán fortress outside Cuzco. (See page 44). Photo: Robert Frerck, Odyssey Productions, Chicago.

Back Cover:

View of San Antonio de Oriente

José Antonio Velásquez (Honduras, 1906–1983), 1971. Oil on canvas, 52" x 66" (132 x 168 cm). Collection of Pedro Perez Lazo, Caracas, Venezuela. Photo: Angel Hurtado. (See page 2.)

Maya-Toltec, Observatory and Pyramid of Kukulcán.

The building used by the Maya-Toltec people to study the stars, and their great pyramid, are shown through a stone doorway.
(See chapter three, pages 48 and 49.)

Chichén Itzá, Yucatán, Mexico, 987–1204 AD. Stone. Photo: Karen Durlach.

CONTENTS

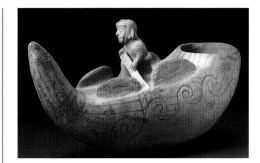

Preface . 1

1 ECHOES OF YESTERDAY

Diversity . 2

Early Cultures in Middle America 6

Early Cultures in South America 11

Studio Activity: Making a Pottery Vessel 14

Indian Life Disrupted 15

2 ART AND RELIGION

Finding Clues in Ancient Art 20

Studio Activity: Making a Picture Book 23

Pre-Columbian Myths and Legends 26

Influences from Europe 34

3 BUILT TO LAST

Pyramids and Other Stonework 38

Studio Activity: Building a Pyramid-Temple . . . 45

Palaces and Humble Homes 46

Observatories and Astronomy 48

Building Churches . 52

Other European Structures 58

4 A LOVE OF COLOR

Pre-Columbian Murals 60

Murals After the Conquest 62

Murals in a Time of Transition 64

Twentieth-Century Murals 66

Textiles . 71

Studio Activity: Stamping Designs on Fabric . . 75

Moche, Vessel in the Form of a Reed Boat
A clay Moche vessel describes fishing boats built out of bundles of totora reeds. Peruvian fishermen build similar boats today. (For information on the location and time periods of the Moche and other ancient cultures, see the map on page 3 and the timeline on page 19.)

South America, Peru, 400–600 AD. Ceramic, about 6" x 5" x 14 3/4" (15 x 13 x 37.5 cm). Gift of Nathan Cummings, 1957.612. ©2000 The Art Institute of Chicago, All Rights Reserved.

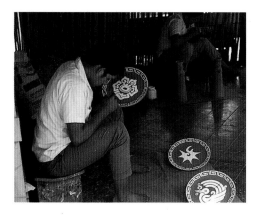

Mexican Craftsmen at Work
The careful labor that goes into the making of folk art is illustrated by two Mexican artists painting ceramic pieces. (For more on Latin American folk art, see chapter six.)

Uxmal, Mexico, 1971. Photo: Seymour Chaplik.

5 CEREMONIAL ART

Metalwork and Jewelry 76

Masks . 79

Studio Activity: Creating a Festival of Masks . . 81

Music and Dance . 82

Animal Imagery . 85

6 EVERYDAY LIFE IN ART

Pre-Columbian Lifestyles 88

Colonial Life . 91

Folk Art . 95

Studio Activity: Making a Cut-Paper Mola 99

Artists of Today . 100

7 THE MODERN WORLD

National Roots . 104

Universal Interests . 108

Studio Activity: Constructing a Collage 113

Resources

Glossary of Terms . 114

Guide to Pronunciation . 116

Selected Bibliography . 118

Index . 120

PREFACE

The word *Latino* connotes rich artistic, cultural, and racial diversity, which may come as a surprise to many non-Latinos. Indeed, Latinos themselves are often unaware of this diversity. This is partly due to the large geographic distances that separate Latin American countries and to the nationalistic views of each region. In addition, communication within each country is not always in Spanish, since Portuguese, French, or English is the major language in several countries.

People in the United States often use the term "Hispanics" to lump together a group of people they believe to be homogeneous. Of course, nothing could be further from the truth. Latin America is a multicultural mosaic with at least 500 years of influences from Africa, Europe, and Asia. The term "Hispanic" recognizes only the colonialist Spanish influence in the Americas, while ignoring the indigenous, black, and other populations that have contributed to and influenced Latin America.

An example of black influence dates back to when the Spanish first came to the Americas and brought about 250,000 African slaves to Mexico. Then, in 1610, in Mexico, the African leader Yanga and his indigenous allies established the first town in the Americas to be free from slavery.

Latin American Arts and Cultures is one of the first books directed to young audiences that focuses on the region's arts, cultures, and religions, and their complex, intertwined relationships. The author has had considerable experience in writing about Latin American art and history. Her book shows us how the Maya civilization excelled in astronomy and mathematics. It explores the Nazca's monumental sand designs that can be seen only from the sky. It describes the development of architecture, sculpture, and painting from ancient times to the present, including pyramids and palaces, Christian churches and colonial life, muralism and folk art.

The reader will come away with the realization that while much of Latin America shares a common language and history, it is made up of many diverse populations. The plurality, vitality, and diversity of these populations provide the substance of this comprehensive look at Latin America's artistic contributions to the world from 3000 years ago to the present.

René Hugo Arceo
Visual Arts Coordinator, Chicago Public Schools

Reading
Under the bright Puerto Rico sun, a group of adults read together. The tight circle of chairs opens at one point and leads our eye into the background of rich foliage and flowers. Can you find a connection between the readers and the background that tells you how the artist felt?

Rafael Tufino (Puerto Rico; b. New York, 1918), 1974. Poster, 26 $\frac{1}{2}$" x 19" (67.3 x 48.2 cm). Collection of the author. Photo: Dorothy Chaplik.

DIVERSITY

> Diversity began with Latin America's earliest people, who may have come from Asia between 10,000 and 35,000 years ago or more. New theories develop as archaeologists make new discoveries.

LATIN AMERICA is not a single country with a single identity. It consists of many countries, each with its own unique character. Mexico and the countries of Central America are referred to as Middle America (or Mesoamerica). South America includes everything below the narrow country of Panama. Islands in the Caribbean Sea are also part of Latin America. Latinos generally refer to themselves as Argentine, Bolivian, Cuban, Guatemalan, Mexican, and so forth, after their country.

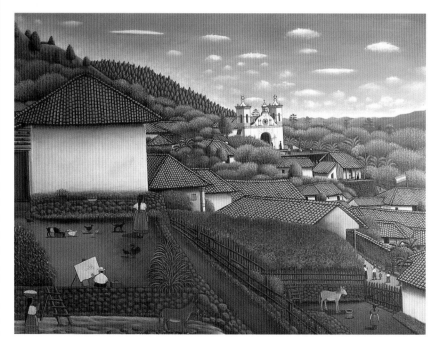

View of San Antonio de Oriente
An artist's view of his mountain village in Honduras depicts the rural life of many Latin American countries. Raising food, flowers, and animals is part of the daily routine. Religious and social activities take place in the nearby twin-towered church. Can you find the artist's self-portrait?

José Antonio Velásquez (Honduras, 1906–1983), 1971. Oil on canvas, 52" x 66" (132 x 168 cm). Collection of Pedro Perez Lazo, Caracas, Venezuela. Photo: Angel Hurtado.

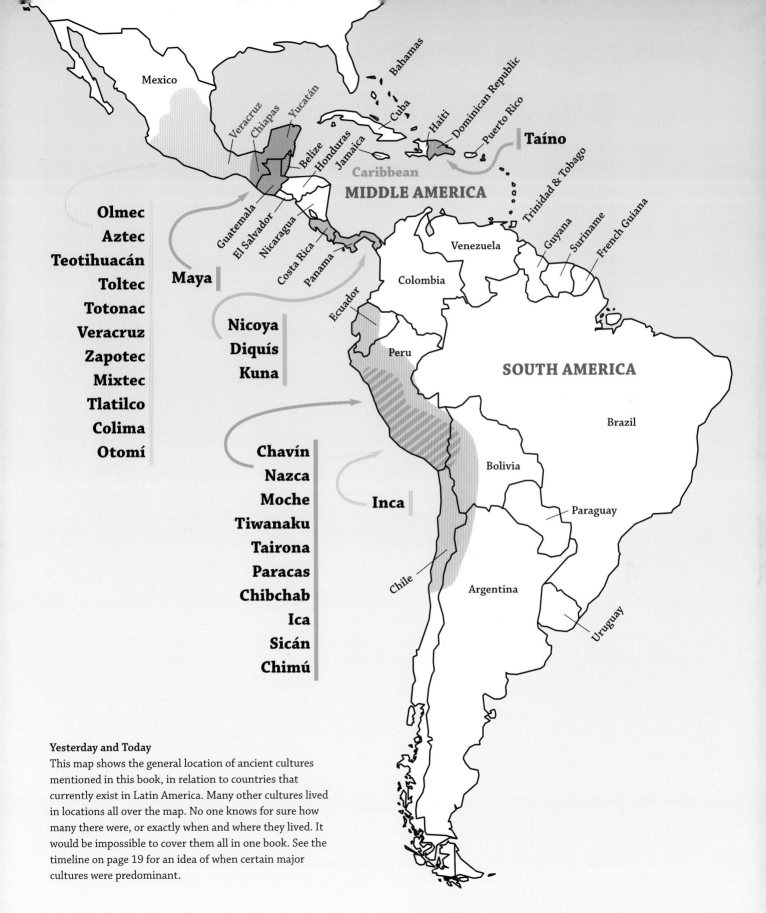

Mexico

Veracruz
Chiapas
Yucatán
Belize
Honduras
Jamaica
Guatemala
El Salvador
Nicaragua
Costa Rica
Panama

Bahamas
Cuba
Haiti
Dominican Republic
Puerto Rico
Taíno

Caribbean
MIDDLE AMERICA

Trinidad & Tobago
Guyana
Suriname
French Guiana

Venezuela

Colombia

Ecuador

Peru

SOUTH AMERICA

Brazil

Bolivia

Paraguay

Chile

Argentina

Uruguay

Olmec
Aztec
Teotihuacán
Toltec
Totonac
Veracruz
Zapotec
Mixtec
Tlatilco
Colima
Otomí

Maya

Nicoya
Diquís
Kuna

Chavín
Nazca
Moche
Tiwanaku
Tairona
Paracas
Chibchab
Ica
Sicán
Chimú

Inca

Yesterday and Today
This map shows the general location of ancient cultures
mentioned in this book, in relation to countries that
currently exist in Latin America. Many other cultures lived
in locations all over the map. No one knows for sure how
many there were, or exactly when and where they lived. It
would be impossible to cover them all in one book. See the
timeline on page 19 for an idea of when certain major
cultures were predominant.

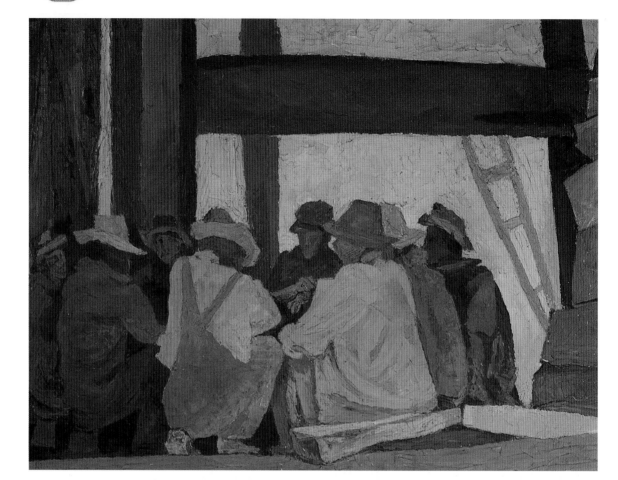

Breakfast (El desayuno)

In Mexico, as in other Latin American countries, many men work at construction jobs to earn a living. Notice how the artist used building materials to frame some of the laborers.

Pablo O'Higgins (Mexican citizen, b. US, 1904–1983), 1945. Oil on canvas, 29 1/$_2$"x 38" (75 x 96 cm). Reproduction courtesy of the María and Pablo O'Higgins Cultural Foundation. Collection of Museo de Arte Moderno, Mexico, D.F. Photo: Paulina Lavista.

The population of each country includes different percentages of Indian, African, European, and Asian people, who speak a variety of languages and experience separate cultures. Diversity exists even when the population is strongly Indian. (In Latin America, "Indian" usually refers to native tribes, not people from India.) Original native groups followed separate customs, religions, and languages. Today, many descendants maintain the old traditions. They may share a common language, but because they live in different regions of a country, they speak in different dialects, or speech patterns. For example, in Mexico today, Indians from the Yucatán lowlands and Indians from the highlands of Chiapas have difficulty understanding one another's language, even though they are both Maya-speaking people.

The geography and climate of each country create other differences. Long mountain chains running through Middle and South America create snow-capped highlands, where freezing temperatures prevail. Elsewhere, in great valleys, temperatures vary from warm

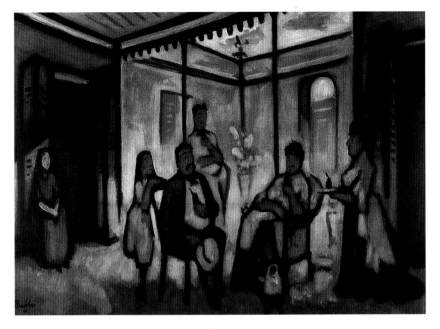

Maté in the Family Patio (Maté en el patio familiar)
An artist from Argentina portrays well-dressed people enjoying an after-dinner beverage and relaxed conversation in elegant surroundings. Maté is a popular Latin American herbal drink, enjoyed by rich and poor alike. It is usually served in a gourd *(calabaza)* with a straw *(bombilla)*.

Horacio Butler (Argentina, 1897–1982), 1964. Lithograph. Collection of Dr. and Mrs. Jorge Schneider, Chicago, Illinois. Photo: Seymour Chaplik.

to tropical. Stretches of bleak deserts, smoldering volcanoes, teeming jungles, and tropical rain forests cause some areas to remain sparsely populated or unoccupied.

Land and climate often dictate how people make their living. They account for such different occupations as fishing, mountain farming, the raising of goats, llamas, and other animals, and leather-making. Weaving and various arts and crafts are practiced almost everywhere. In every region, in communities large or small, Latin Americans work in the legal, medical, scientific, and teaching professions, and in the industries needed to maintain life in a modern era.

Whether in the highlands or lowlands, communities vary in size and character. In some villages, life is simple and primitive. In and around larger cities, lifestyles can include more of the modern conveniences. However, cities also have poverty and crowded living conditions. Broad differences exist between the incomes of the rich and the poor throughout Latin America.

Dress is as varied as language or occupation in Latin America's larger cities. Men and women wearing New York or Paris fashions can be seen alongside Indians in traditional styles worn by their ancestors.

Yet, these separate, unique countries are bound together, not only by geographic closeness, but by their common history and centuries of expressing themselves through art. Perhaps it is through its art that the diversity of Latin America can be seen most clearly.

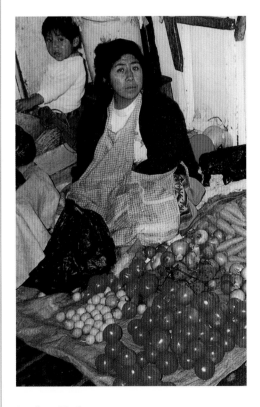

Produce Market
A twentieth-century woman displays her vegetables at a marketplace in Peru.

Cuzco, Peru. Photo: James Westerman.

Latin America is a place of many contrasts. Cultures from the ancient past have had a strong influence on the cultures of today.

EARLY CULTURES IN MIDDLE AMERICA

THERE ARE MANY UNANSWERED QUESTIONS about the earliest people to live in Latin America. When did they arrive? Where did they come from? The first people may have reached Alaska from Asia by crossing the Bering Straits on foot when it was a land bridge. Over many centuries, some moved southward to roam through lands we know today as Latin America. Another possibility is that the first people traveled by boat across the Pacific Ocean and rafted down the western coast of the North American continent. No doubt these early explorers moved as they needed to find food, stopping wherever they found animals and plants. After long periods of wandering separately, people formed tribes and communities, each with its own religion, customs, and language. We refer to these communities as cultures. Larger, more organized cultures are also called civilizations. From surviving works of art and architecture, we learn of their history and beliefs.

What is known today about any early group is incomplete and subject to change when new discoveries are made. For example, it wasn't until the middle of the twentieth century that linguists, art historians, and archaeologists broke the complicated Maya hieroglyphic code. Until then, scholars could read only numbers and dates. They knew the Maya system was based on the number twenty, the count of a person's fingers and toes—the way many children learn to count. Today, the code is more fully understood. Each new discovery changes what is known about a civilization, and scholars sometimes disagree on the historical effect of new findings. Therefore, dates given in this book are approximate guidelines for the reader.

Maya, Seated Female Dignitary
The importance of this Maya woman is reflected in the dignity of her posture, as well as in her handsome dress and jewelry. Her large earspools are typical decoration for both men and women among the early cultures.

Mexico, 500–800 AD. Pottery, height: about 6 $\frac{1}{2}$" (16.5 cm). Courtesy Richard Gray Gallery, Chicago, Illinois. Photo: Davis Art Slides.

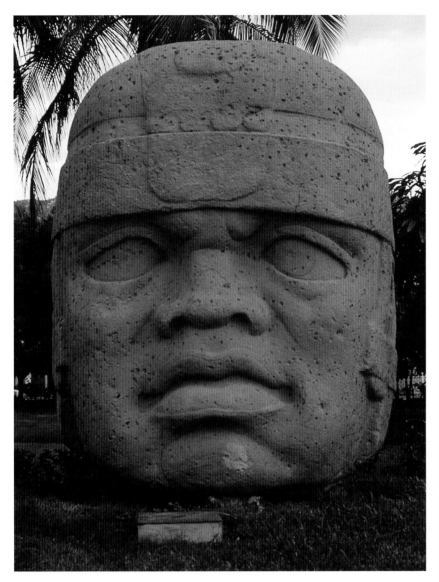

Olmec, Colossal Stone Head
This large sculpture is probably a portrait of an important Olmec leader. Stone is not available in the regions where enormous heads like this one were discovered. This means the Olmec had to transport huge amounts of stone from some distant point, perhaps in part by raft.

Tabasco, Mexico, 800–400 BC. Basalt, height: about 8' (2.4 m). From LaVenta, now at Villahermosa. Photo: Davis Art Slides.

The **Olmec** culture was the first organized civilization in Middle America that we know about. They emerged about 1500 BC and disappeared around 100 AD. It is called the "mother culture" because of their strong influences on the art, architecture, and religion of other cultures that followed. The Olmec possessed great vitality and imagination. Their culture extended from the Gulf coasts of present-day Mexico to southwest Mexico and to western El Salvador. Stone portrait heads, each weighing about twenty tons, have been discovered at Olmec centers. Also found were small human figures, finely carved in stone.

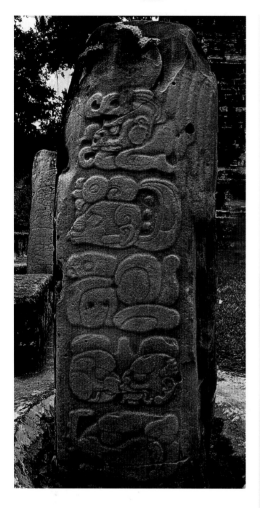

The **Maya** culture, which began about 800 BC, expanded on the achievements of the Olmec and became a great civilization. Their territory ranged from what is today southeast Mexico, through Guatemala to Honduras and El Salvador. The Maya had a profound understanding of mathematics and astronomy. They devised an accurate calendar and developed a complex system of hieroglyphic writing. Like the Olmec, their knowledge and art influenced other cultures. For unknown reasons, the Maya culture went into a decline in the tenth century AD in certain parts of Mexico and Guatemala. Many of their people migrated to other regions.

The **Teotihuacán** culture lasted from about 150 BC to 750 AD. Although this was a shorter time period than the Maya or Olmec cultures, much was accomplished by these people. The City of Teotihuacán, located near what is now Mexico City, became the largest urban center in the Americas. It existed about the same time as the Roman Empire and was comparable in size. It was the first Middle American city built on a grid pattern, and covered about eight square miles.

Because of its closeness to the surrounding mountains and rivers, Teotihuacán was considered a sacred city. Its religious center included pyramids dedicated to the moon and the sun, and to a feathered serpent god believed to be part bird and part snake. This god was worshiped by every culture in Middle America. Teotihuacán artists were skilled in featherworking, pottery making, and mural painting.

Other cultures flourished and waned throughout Middle America for 3000 years, including the Toltec, Totonac, Veracruz, Zapotec, Mixtec, and many more peoples. Some disappeared mysteriously, perhaps due to natural disasters, such as storms or earthquakes. The eruption of volcanoes could swallow up whole villages. Some cultures may have perished from drought, famine, or disease. Others fought wars, with stronger forces absorbing the weaker cultures.

Maya, Stela
A stela is a stone monument, also known to be a time marker. Hieroglyphic writing carved on three sides offers a description and the time (month, day, and year) of an important Maya event. It also states that the stela was erected under the authority of a king named Jaguar.

Tikal, Guatemala, 300–630 AD. Stone. Photo: Davis Art Slides.

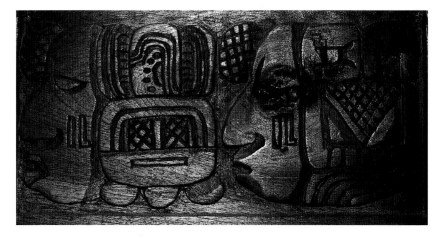

Relief Carving
A twentieth-century artist asserts pride in his heritage by recreating the glyph writing of his Maya ancestors.

Eliezer Canul (Mexico; b. 1927), 1970. Wood, 6 ¹/₂" x 12 ¹/₂" (16.5 x 31.75 cm). Collection of the author. Photo: Dorothy Chaplik.

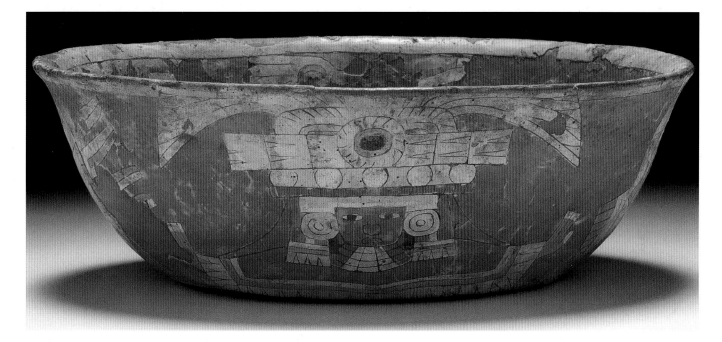

Teotihuacán, Bowl
On the front of this bowl, a seated figure wears a feather-trimmed robe and headdress, a collar necklace, and large ear ornaments. The artist used a fresco technique that involved covering a clay bowl with wet plaster and painting it before the surface dried.

North America, Teotihuacán, Mexico, 450–750 AD. Ceramic, diameter: about 8 ¹/₂" (22.5 cm). Primitive Art Purchase Fund, 1968.790. ©1999 The Art Institute of Chicago. All Rights Reserved. Photo: Robert Hashimoto.

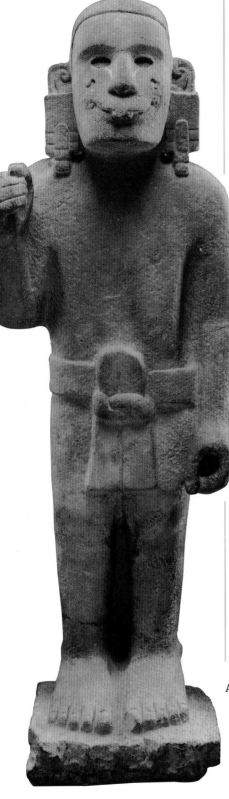

By the time Spanish conquerors arrived, in 1521 AD, the **Aztec** culture (also known as the Mexica) dominated most of Middle America. When the conquistadors entered the capital of the Aztec empire, they were amazed to find a city with carefully laid-out streets and soundly built bridges. A system of aqueducts carried water throughout the city, which helped beautiful gardens to flourish despite a dry climate. Their architecture was constructed of solid stone and decorated with colorful wall paintings.

The Aztec had not always been literate and artistic. Two hundred years earlier, they were a small, nomadic tribe of primitive Indians. After founding Tenochtitlán (now Mexico City) and transforming it from a marshy swamp to a solid, habitable city, the Aztec proceeded to conquer the powers around them. Their genius was in their ability to absorb all the learning and skills of the conquered peoples into their own culture. Under Aztec rule, the official language was Náhuatl, but each culture also retained its own language.

In Cuba, Haiti, Puerto Rico, the Dominican Republic, and other islands in the Caribbean Sea, the **Taíno** culture flourished. They were agricultural people whose ancestors had inhabited the islands for thousands of years. The Taíno was an active culture between 1200 and 1500 AD. They were the first Americans to have contact with Spanish explorers led by Christopher Columbus in 1492. (See Taíno artwork on page 21.)

Aztec, Standard-bearer

This figure, dressed as a simple worker, originally held a flagpole for displaying banners. Two such figures stood at the entrance of an Aztec temple to announce festivities honoring a particular god. Facial scars were a sign of bravery, while teeth filed to points were marks of beauty.

Huastec region, Veracruz, Mexico, 1425–1521 AD. Stone, height: 47 $^7/_{16}$" x 16" x 13 $^1/_4$" (120.5 x 40.6 x 33.7 cm). The Museum of Fine Arts, Houston, Texas; Gift of D. and J. de Menil.

EARLY CULTURES IN SOUTH AMERICA

IN SOUTH AMERICA, the **Chavín** people are considered the mother culture of early civilizations. They flourished in the central highlands of ancient Peru in the Andes Mountains between 900 and 200 BC. They worshiped a feline deity that appeared frequently in their art and architecture. This deity turned up in artwork of later cultures as well. The ceremonial center of this culture, called Chavín de Huán-tar, is known for its great temple and fine stone sculptures of jaguars, eagles, and other Chavín deities.

The **Nazca** culture developed between 200 BC and 600 AD in southern Peru. Their western boundary was the Pacific Ocean. To the east were the Andes Mountains. The Nazca people are known for the high technical and artistic quality of their ceramics and textiles, which lasted through the centuries thanks to the dry desert climate. Like the other Peruvian cultures, the Nazcas had no writing system and left no history, except for their art. In the Nazca desert, they left huge animal, human, and geometric line drawings. Many of their vessels are decorated with abstract geometric designs.

In South America, the earliest civilizations took shape on the Pacific Coast in the area known as ancient Peru. Today that area includes parts of modern Ecuador, Peru, and Bolivia.

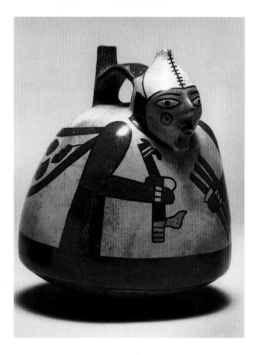

Nazca, Single Spout Effigy Bottle
Effigy vessels containing food and drink were buried with the dead, believed to nourish them in an afterlife existence. The painting on this vessel describes a Nazca warrior, perhaps the deceased. He holds arrows in one hand and carries a backpack, possibly containing chili peppers.

South America, Peru, South Coast, 400-500 AD. Ceramic, height: about 6 3/4" (16.8 cm). Gift of Nathan Cummings, 1957.617. Photograph by Kathleen Culbert-Aguilar, ©2000 The Art Institute of Chicago. All Rights Reserved.

Chavín, Vessel
Chavín art is known for its simple and elegant beauty. This bowl is decorated with carved abstract lines that suggest the form of a feline (any member of the cat family, for instance, a jaguar). Look for curving lines that resemble a cat's tail. The feline had religious importance to most early cultures in Middle and South America.

North Coast of Peru, Cupisnique style, 900–600 BC. Steatite, about 2 1/2" x 3 1/2" (6.6 x 9.3 cm). ©2000 The Cleveland Museum of Art. Purchase from the J.H.Wade Fund, 1955.167.

Moche, Portrait Vessel of a Ruler
Moche portrait vessels were usually made in a two-piece mold, which allowed artists to create three-dimensional contours and a lifelike image. The hollow tube handle and spout on the bottle helped coastal people save water on trips across desert land. Any evaporating mists caught in the horizontal tube would drop back into the jug's water supply.

South America, Peru, North Coast, 400–600 AD. Frontal View. Earthenware with pigmented clay slip, 14" x 9 1/2" (35.6 x 24.1 cm). Kate S. Buckingham Endowment, 1955.2338. Frontal view. ©2000 The Art Institute of Chicago. All Rights Reserved.

About 500 miles north of the Nazca, along the same dry desert coast of Peru, the **Moche** (or Mochica) people thrived from 100–700 AD. Thanks to their ancient custom of burying objects with the dead, treasured works of art have been found in Moche cemeteries over the centuries, some very recently. The shapes of Moche gold and pottery, as well as their painted decorations, were realistic-looking. This helps us glimpse the lives of these people—how they looked, how they hunted, fished, and how they defended themselves in war.

Both the Moche and Nazca civilizations were affected by the **Tiwanaku** (or Tiahuanaco) people. This was a powerful culture that flourished between 400–800 AD. They interacted and traded with the Moche and Nazca peoples, and were involved in their downfall. The capital city of Tiwanaku, high in the Andes, was a great center of wealth and power, and was the seat of ruling kings. An artificial moat surrounded the city and made it a sacred island.

Among the many other cultures that developed and dispersed over the years were the Tairona, Paracas, Chibchab, and Ica. By the sixteenth century, when the Spanish arrived, the powerful **Inca** empire had conquered all its neighbors and reigned over lands known today as Peru, Bolivia, Ecuador, and parts of Colombia, Chile, and Argentina. It may have emerged in 1400 AD, although some scholars believe it existed earlier.

The Inca believed their king was the son of the sun god and, therefore, had the divine right to rule. Inca men displayed their superior status over the conquered people by wearing extremely short hair. This set them apart from the men of other groups, who wore long hair in some form. The Inca also dressed in fine clothing. Atahuallpa, the last of the Inca rulers, was wearing a shirt woven of fiber spun from bat fur when he was captured by the Spanish.

The Inca also adorned themselves with gold jewelry, since gold was the color of the sun and symbolized divinity. Metal workers were skilled in creating objects in pure gold, or pure silver, as well as combining different metals. The Inca were also expert stone masons, known for their monumental architecture. Structures were often built by fitting together huge stone blocks without mortar.

Like the Aztecs, the Incas had come to power by conquering neighboring cultures. They absorbed the knowledge and technical skills of the conquered people, while allowing them to maintain their native cultures. The Incas demanded that official communication be carried out in their own Quechua tongue, but the defeated people spoke among themselves in their own languages.

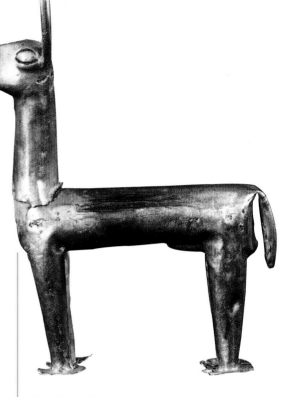

Inca, Llama Figurine
The delicate artistry of this tiny gold piece suggests it may have been a personal ornament. Possibly it was buried with its owner at death. Living white llamas were sacred symbols and were sometimes sacrificed to the Inca sun god.

Peru, Bolivia, Chile or Ecuador, 1400–1532. Hammered gold, 2 1/2" x 1 3/4" (5.2 x 4.2 cm). ©2000 The Cleveland Museum of Art. Gift of W.J.Gordon, 1955.374.

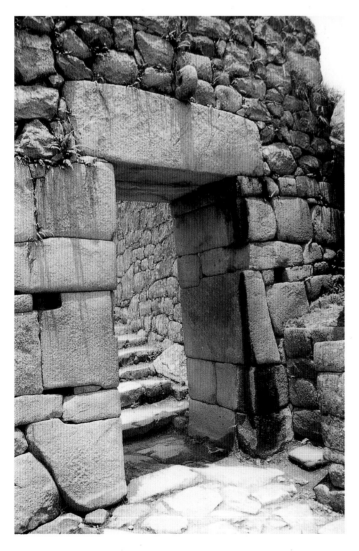

Inca, Main Entrance into Machu Picchu
Mortar is a cement-like substance commonly used like glue to hold stones or bricks together. Inca stone masons, however, fit together immense stone blocks without mortar. Any irregular surfaces were carefully ground down with hand-held stones to achieve a perfect fit. Inca buildings were stable enough to withstand frequent earthquakes.

Peru, 1400–1532. Stone masonry. Photo: James Westerman.

STUDIO ACTIVITY

Making a Pottery Vessel

LIKE MANY EARLY CULTURES, Nazca potters used the coil method to build most of their pottery vessels. Sometimes they shaped the pot directly out of a lump of clay. In this activity, you will make a coiled pot. You might want to add a handle and spout, like the Nazca pot on page 11. To begin your pot, follow these basic steps:

1 Begin by forming the base of the pot with a flat, round shape of clay about 1/2-inch thick. Next, roll clay into long, 1/2-inch-thick strips (coils).

2 Press each coil one at a time onto the edge of the base, coiling it around. Add more coils as needed by pressing their tips together. To make the coils stick together better, potters *score* the clay and add *slip,* which acts like a glue.

3 Think about the shape of your pot. If you want the sides to bulge out, place each coil on the outer edge of the coil beneath. As you work, keep smoothing the inside and outside of the pot. Nazca potters smoothed the clay walls with wooden trowels, flat stones, or bits of cloth. You can use your fingers, spoons, or other tools.

WORDS TO KNOW:

score In clay work, artists score grooves or make scratches in surfaces of clay that will be joined together.

slip Clay, thinned with water or vinegar, to form a thick liquid. Slip is used on scored areas to join pieces of clay together. Slip can also be used like paint on leather-hard ware.

OPTIONS

- Once you've formed the basic shape, you can add a handle and a spout. To make them hollow, press clay around a pencil or one of your fingers. For the flow of liquid, cut an opening on the pot where you want to join the spout. Add all parts while everything is still damp, using slip as needed.

- To decorate the vessel with an incised design, allow the pot to become dry and almost like leather. It should be hard enough to hold its shape but not too hard to cut into easily. Nazca artists often used pointed bone tools, thin reeds, and sometimes their thumbnails. What objects will you use?

- For further decoration, the Nazca people painted their vessels with a thin layer of colored slip before firing. They applied as many as twelve colors to one vessel. If you fire your vessel in a kiln, you can paint your pottery with glazes. Otherwise, use acrylic paints.

INDIAN LIFE DISRUPTED

IT IS HARD TO IMAGINE what life was like hundreds of years ago, before telephones, televisions, airplanes, and computers. Without communication or knowledge of other cultures, the people of each civilization lived as if only theirs existed. Once Columbus made the link to unknown lands in the Americas, a flood of European adventurers rushed to follow his lead. Motivated by the search for riches, they were armed and ready to fight. Before long, even the strongest native cultures were overpowered. This period of invasion, referred to as "the conquest", radically changed native lifestyles.

The new rulers imposed their religion, customs, and languages on the ancient peoples. Many adapted to the conquerors' demands.

With the arrival of Spanish conquerors in the sixteenth century, Indian life radically changed. Their lands became colonies of Spain, Portugal, and other European countries. The conquerors named parts of Mexico and Central America "New Spain".

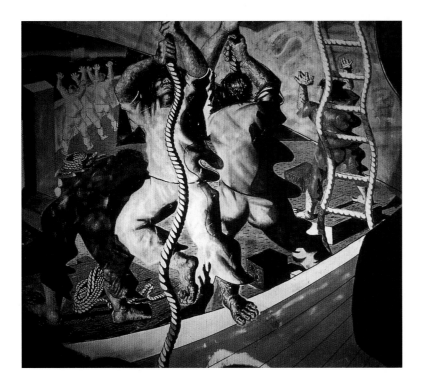

Discovery of the Land
A twentieth-century Brazilian artist imagines a ship that brought men from Spain and Portugal to the newly discovered lands. The movement of their strong hands and feet expresses the sailors' excitement as they see land and struggle with the twisting ropes.

Candido Portinari (Brazil, 1903–1962), 1941. Mural, dry plaster with tempera. Murals at Hispanic Foundation, Library of Congress, Washington, DC. Photo courtesy of the Library of Congress.

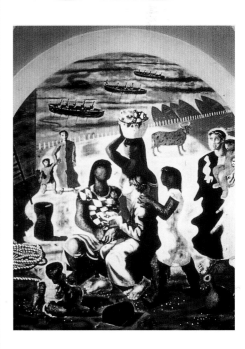

Teaching of the Indians
After the conquest, missionaries arrived to Christianize the natives. This mural shows robed monks teaching Indian women and children. The Brazilian coastline is a reminder that the conquerors arrived by boat.

Candido Portinari (Brazil; 1903–1962), 1941. Mural, dry plaster with tempera. Murals at Hispanic Foundation, Library of Congress, Washington, DC. Photo courtesy of the Library of Congress.

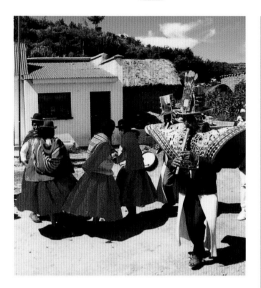

A Modern Celebration
Modern Bolivians celebrate a festival in costumes that combine ancient and colonial styles.

Challapampa, Island of the Sun, Bolivia, 20th century. Photo: James Westerman.

Others clung silently to their old religious beliefs as they saw their temples destroyed and were forced to convert to Christianity. In many cases, Indians interpreted the Christian saints as new forms of their old deities. In time, the two cultures—Indian and European—merged.

By the nineteenth century, people began rebelling against foreign rule and fought wars for their independence. Boundaries were established for the countries in Latin America, and they entered the modern era as independent nations.

Descendants of the original civilizations still live today in various Latin American countries. Some strictly follow the old customs, while others mix past and present in their habits and dress. In the highlands of Bolivia, men wear traditional knitted caps with ear flaps and brightly colored ponchos, often over European-style pants and

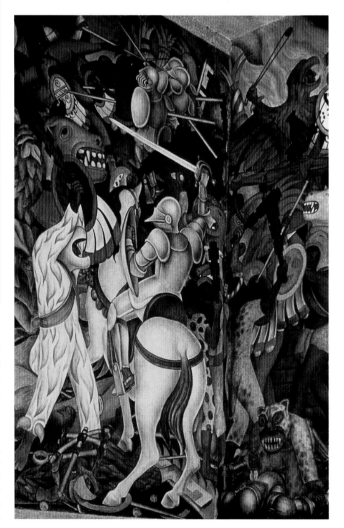

The Spanish Conquest (La conquista española)
An actual battle between Spanish soldiers and Aztec warriors took place near where this mural was painted, at the Cortés Palace. Indian fighters on foot wear animal skins and carry wooden clubs, while Spanish soldiers wear full armor, ride horses, and hold steel swords and shields.

Diego Rivera (Mexico; 1886-1957), 1929. Fresco, detail of mural, Cortés Palace, Cuernavaca, Morelos, Mexico. ©2000. Reproduction authorized by El Instituto Nacional de Bellas Artes y Literatura; and el Banco de Mexico, Fiduciary in the Trusteeship of the Museos Diego Rivera y Frida Kahlo (Av.5 de Mayo No. 2, Col. Centro, 06059, Mexico, D. F.). Photo: Davis Art Slides.

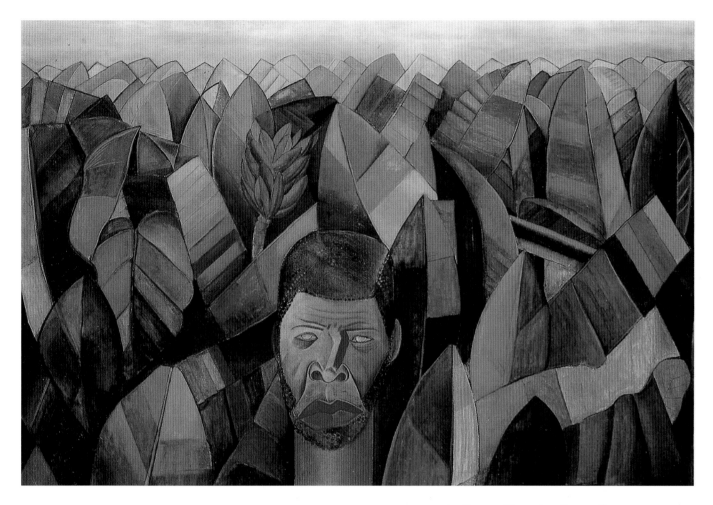

Banana Plantation (Bananal)
This artist portrays the racial blending that occurred after slavery was abolished in Brazil, when Africans became absorbed into Brazil's population. The central figure is a plantation laborer who reflects the combined features of the African, Indian, and European races.

Lasar Segall (born Vilnius, 1891; died Brazil, 1957), 1927. Oil on canvas, 34 ¹/₄" x 53" (87.6 x 134.6 cm). Collection of Museu Lasar Segall, São Paulo, Brazil. Photo courtesy Pinacoteca do Estado de São Paulo, Brazil.

shirt. In Mexico, many women wear rebozos—woven shawls in the colors and patterns of their tribes—over modern, everyday clothing. Special costumes are used to celebrate ancient holidays, while more modern clothing is worn at Christmas and Easter.

After the conquest, European settlers added to the mix of customs, dress, and language. In most areas a strong Spanish influence developed, but in certain regions settlers created a distinct Portuguese, French, English, or Dutch atmosphere. Their influence is still seen in the architecture and customs of those countries.

However, the immigrants' strongest contribution is in the racial mix of the population. Throughout Latin America there are large numbers of mestizos—people of mixed European and Indian blood. In Brazil and other countries where African laborers were brought over by the conquerors, there is a large mulatto population—a mixture of African and European blood. There is also a growing number of Afro-mestizos—a mixture of all three races.

Celebrating Hispanic Month

A modern Mexican artist portrays elements from pre-Columbian times and from the Spanish-influenced colonial period. An ancient pyramid-temple is bordered by symbols of both the old and the new worlds. The mixture of these elements have shaped the character of today's Mexico, and much of Latin America, as well.

Renato Esquivel (Mexico; b. 1953), 1998. Poster. Collection of the author. Photo: Erin Culton.

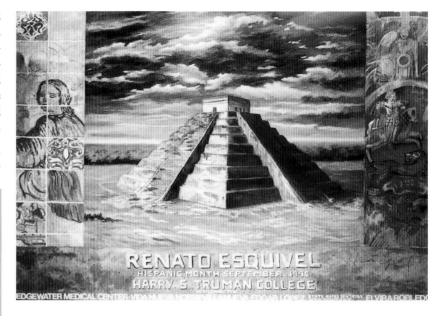

Latin America Cultural Timeline

For many centuries before the conquest, different cultures shared or fought for the lands of Latin America. The map on page 3 shows where some of these cultures lived. The timeline at right shows approximately when certain cultures emerged and declined. Which cultures of Middle America existed at the same time as cultures in South America? Do you think they ever met one another? Timeline drawings are taken from artwork found in ancient murals and on clay seals and body stamps. What does this artwork tell you about the lives of these early people?

Because many immigrants who arrived after the conquest spoke in languages rooted in Latin, the new lands became known as Latin America. Their languages, together with the numerous Indian and African tongues spoken, contributed to Latin America's early multilingualism.

More recently, immigrants from Asia and people fleeing wars in Europe have added to the medley of voices. Although Spanish is the official language in most Latin American countries, pure Castilian Spanish—the standard form of the language spoken in Spain—is seldom heard anywhere. Foreign words and accents tend to creep into a language and change its vocabulary and pronunciation. In Brazil, Portuguese is the official language. In Haiti, French is dominant. Dutch is primarily spoken in Curaçao, and in Jamaica, English.

The influx of new peoples and new languages has enriched and strengthened Latin America, while making its cultural identity more complex. Still, the dominant features of Latin American culture come from the fusion of the ancient Indian cultures with the European civilization in the sixteenth century. The fusion is seen today in the way mestizo, mulatto, and Afro-mestizo populations uphold both ancient and modern customs. Countless works of art and architecture reflect this blended heritage.

Today, Latin America shares in the world's technological advances. Its art and architecture have taken on international styles and reflect concern with world-wide social and political problems, adding yet another dimension to the diversity of Latin American culture.

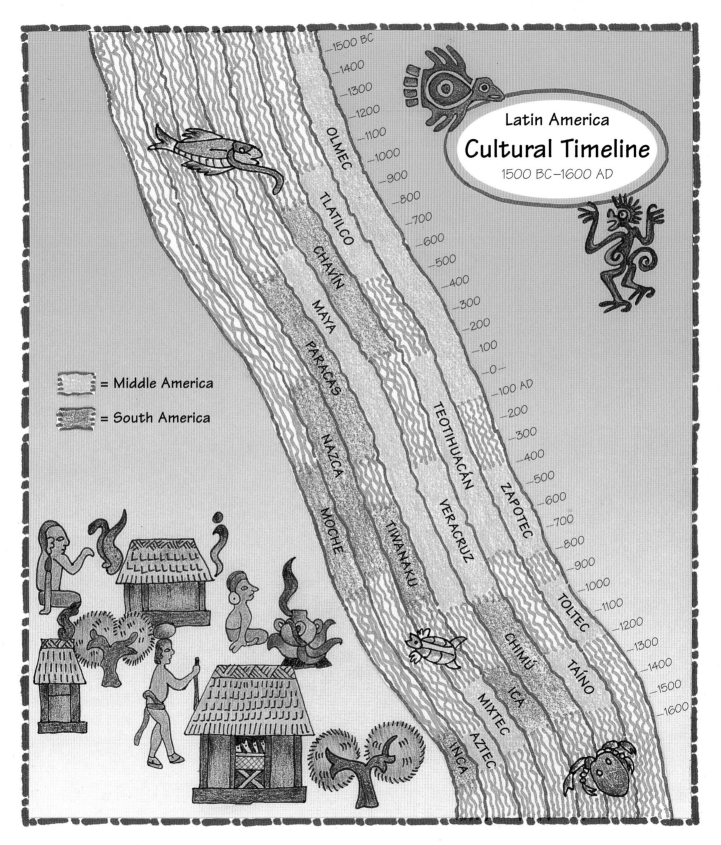

Latin America
Cultural Timeline
1500 BC–1600 AD

= Middle America

= South America

OLMEC
TLATILCO
CHAVÍN
MAYA
PARACAS
NAZCA
MOCHE
TIWANAKU
TEOTIHUACÁN
VERACRUZ
ZAPOTEC
TOLTEC
CHIMÚ
ICA
TAÍNO
MIXTEC
AZTEC
INCA

1500 BC
1400
1300
1200
1100
1000
900
800
700
600
500
400
300
200
100
0
100 AD
200
300
400
500
600
700
800
900
1000
1100
1200
1300
1400
1500
1600

FINDING CLUES IN ANCIENT ART

To separate the history of the Old World from the New World, the name of Christopher Columbus is used. Everything that happened in Latin America before his arrival on October 12, 1492, is known today as pre-Columbian.

THE EUROPEAN EXPLORERS named the lands they found "The New World," but it was actually an old world. Vigorous Indian civilizations had lived there for thousands of years. Much of what we know about the pre-Columbian civilizations comes from their art and architecture. Surviving works of art, often found in fragments or discovered at abandoned Indian sites, have provided considerable information. Pictorial images and glyph writing were carved or painted on stone sculpture, clay vessels, walls, and books. These artifacts provide the clues that help us piece together the history, beliefs, and customs of the early people.

Chavín, Detail from Frieze of Birds
A carving over the doorway of a Chavín temple tells us that ancient Peruvians worshiped birds with snake heads and feline jaws and eyes.

Temple at Chavín de Huántar, Peru, 900–200 BC. Stone carving. Ink drawing by Erin Culton, after Bushnell.

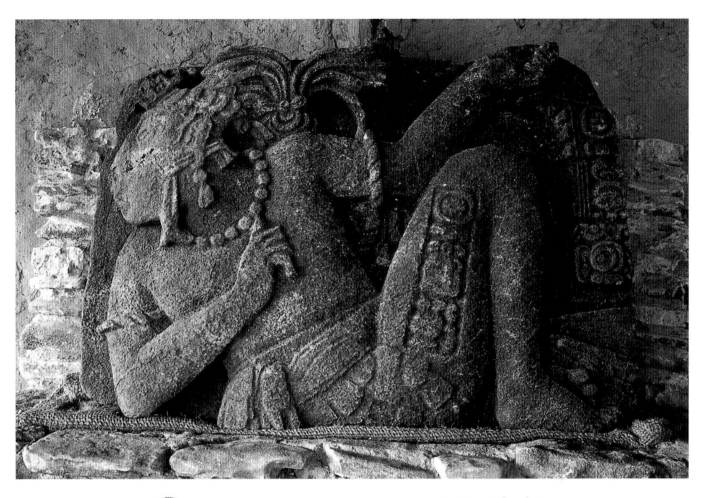

Maya, Relaxed Figure

Ancient works of art tell us a great deal about the people who created them. Glyph writing on this man's thigh identifies him as Kan Xul, a holy lord of the nearby city of Palenque. The monument commemorates a battle waged against him. Ropes around his arms indicate he is a prisoner. His flattened forehead and prominent profile are typical Maya features. Glyphs behind him explain the monument was "planted" by direction of a king named Jaguar.

Toniná, Chiapas, Mexico, c. 715 AD. Limestone. Photo: Davis Art Slides.

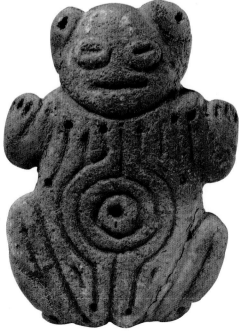

Taíno, Body Stamp and Rattler

This small, bear-shaped piece tells us how Taíno people decorated themselves, usually for religious ceremonies and warfare. Like many early cultures, they used natural pigments to paint the carved stamp, then transferred its designs to their bodies. The stamp was also used as a rattler, to accompany sacred rites.

Dominican Republic, 12th–14th century. Ceramic, height: 3 3/4" (9.5 cm); width: 2 1/2" (6.4 cm). Collection of Mr. and Mrs. Vincent Fay, New York City. Photo: Bruce Schwarz. Courtesy El Museo del Barrio, New York City.

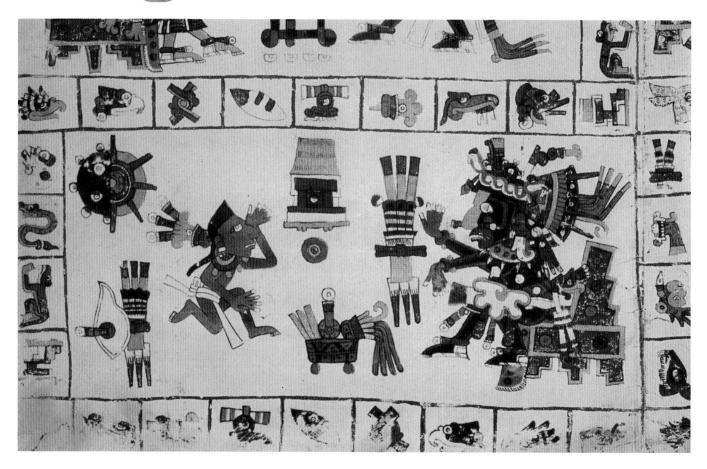

Mixtec, Codex Borgianus, Detail
A Mixtec book page shows a kneeling figure
honoring the feathered serpent god
Quetzalcóatl. The deity wears an elaborate
costume and a plumed headdress. His red
bird-beak mask indicates he is acting as the
wind god, Ehecatl, one of his many roles.
Instead of glyph writing, Mixtec books often
have picture-symbols, like those surrounding
the two main figures.

*Oaxaca, Mexico, 15th century. Animal skin. Now in collection
of Vatican Museums, Rome, Italy. Photo: Davis Art Slides.*

Ancient Mexicans described their world in illustrated manu-
scripts, also known as painted books or codices (the plural form of
codex). Codices were made of strips of cured animal skin or bark
paper. They were folded like a fan or an accordion. Storytelling
scenes were painted on each folded page and explained in hiero-
glyphic writing. Maya glyph writing included nouns and verbs in
complete sentences, while Mixtec books explained events with
picture symbols. The books guided every aspect of the lives of both
ordinary people and the priests and rulers who prepared the books.

After the conquest, the new authorities set out to destroy all
evidence of the old beliefs. By order of the Spanish Inquisition, many
Indian priests were hanged or burned to death. The few people left
who could read the sacred hieroglyphics were forbidden to teach
their skill to their sons. Fortunately, a few codices were sent to
Europe, where they were preserved. Others were hidden in local
regions for several generations.

Making a Picture Book

EARLY CULTURES the world over found ways to record events and tell stories in books. The Romans strapped together wooden tablets, the Egyptians developed papyrus, the Chinese made scrolls out of silk. Ancient Mexicans painted scenes on strips of cured animal skin or bark paper to make books known today as codices. Essentially, each codex is one long strip of paper, folded like an accordian into sections. In this activity, you will make a simple picture book. Later you might want to research more advanced methods.

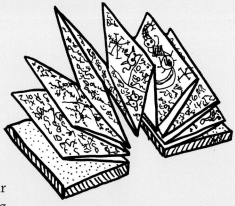

Illustrations by Jean Kropper, from her book *Handmade Books and Cards.*

1 Start with a large sheet of heavy drawing paper. Use a ruler and pencil to divide it evenly into long strips. The height and length of your book will depend on the size of the paper you are using.

2 Cut the paper into strips.

3 Decide how wide you want your pages to be, and start making folds. Fold the paper back and forth until there is not enough paper left for another page. You can trim off the extra paper or, for a longer book, use the extra piece as a tab to glue this strip of paper to another strip.If you want to make a cover, you can use this tab to glue the strip to a heavier-weight cardboard or paper.

4 Now unfold the strip and use crayons, markers, or colored pencils to tell your story with pictures and symbols. Use each folded section to tell an event in your story and continue from fold to fold, like a picture book. If you wish, you can continue the story on the reverse side of the strip.

OPTION

To paint a book, like the ancient artists did, prepare the pages before you fold them. Coat both front and back surfaces of the paper with a layer of gesso. (Gesso, which can be purchased at an art store, is a thin mixture of plaster of Paris, glue, and water). When dry, fold the coated paper into sections. Then use tempera colors to paint your story.

Unusual circumstances led to the survival of the *Popol Vuh,* a sacred text of the Maya Quiché Indians of Guatemala. The book was recorded after the conquest by a Quiché nobleman, Diego Reinoso. He used the Roman alphabet to write Indian words. It was not until the nineteenth century that it was discovered and translated into Spanish by a Dominican monk.

Because the South American cultures did not develop writing systems, we learn about them from pictorial images on their pottery, stone sculpture, and paintings. Both the Nazca and Moche people produced decorated pottery. We know less about the Nazca because they often favored geometric patterns, which are harder to interpret. The Moche used human and animal figures.

Although these cultures did not record their history in writing, they did pass down stories by word of mouth from one generation to the next. A memory device known as the quipu was used by the Inca to recall important events. The quipu consisted of a series of knotted strings of various lengths and colors that hung from a horizontal cord. Quipu "readers" relied on memory to associate certain events with the color and length of the string and the position of the knot. Merchants and traders also used quipus for record-keeping.

After the conquest, descriptions of the ancient cultures were written by soldiers, missionaries, and others. Their eyewitness accounts are interesting, but incomplete, because they did not fully understand the cultures.

Nazca, Effigy Vessel

The shape of this vessel combines human and animal traits. Its human pose shows the closeness felt by the Nazcas toward animals. A whale design appears on the animal's right arm. The vessel may have been filled with food or beverage and used in a religious ceremony.

South America, South Coast of Peru, 1st century BC–4th century AD. Ceramic. 8 7/8" x 5 1/4" x 5 3/4" (22.9 x 13.5 x 14.6 cm). The Metropolitan Museum of Art, The Michael C.Rockefeller Memorial Collection, Gift of Mr. and Mrs. Raymond Wielgus, 1960 (1978.412.53).

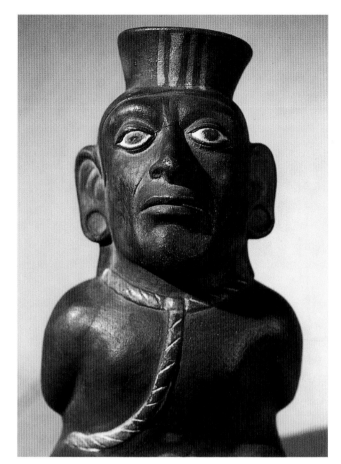

Late Moche, Vessel of a Captive with Hands Bound and Rope Around Neck (detail)

This vessel was found in an ancient grave. It tells us that Peruvian war practices were similar to those in Middle America. To humiliate prisoners of war, the Moche took their jewelry and clothing, and bound their hands behind them with a rope hanging from their necks.

North Coast Peru, 500–700 AD. Ceramic, height: 13 3/4" x 8" x 6 1/4" (34.9 x 20.3 x 15.9 cm). ©The Orlando Museum of Art, Orlando, Florida. Gift of Howard Campbell, 80.061.

Nazca, Quipu

"Reading" the strings and knots on a quipu encouraged good memory and storytelling skills about legends and events. Quipus of different types were used in ancient Peru and perfected by the Inca.

Peru, 1438–1534. Cotton cord. Ink drawing by Erin Culton, after J. A. Mason.

PRE-COLUMBIAN
MYTHS AND LEGENDS

The ancient peoples saw themselves as part of the natural world, together with animal life, the changing seasons, and other forces of nature. They portrayed their gods either in human shapes or as animals.

TO MAKE SENSE OF THEIR LIVES and their environment, the early people developed myths and legends to explain sudden weather changes, droughts, storms, and earthquakes. They believed that a network of gods or spirits with magical powers roamed the earth, the heavens, and the underworld, controlling everything in their domain.

They believed in pairing opposites and often gave their gods a dual function. Gods were seen as responsible for life and death,

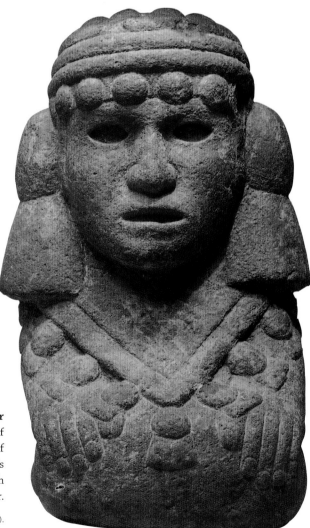

Aztec, Kneeling Figure of Chalchiúhtlicue, Goddess of Water
Chalchiúhtlicue (*chal-chee-UUH-tlee-kway*) is the Aztec goddess of rivers, floods, and oceans. She is the feminine counterpart of Tláloc, the rain god, and is also the goddess of birth. Often she is shown in a skirt decorated with jade, a gemstone associated with water because of its green and blue-green color.

Mexico, 14th–15th century. Stone, 11 5/8" x 7 1/8" x 5 1/2" (30 x 18 x 14 cm).
Metropolitan Museum of Art, Purchase, 1900 (00.5.72).

night and day, earth and sky, fire and water. Some gods were given separate male and female identities. Each culture had different gods, but the major deities in every culture were related to the sun, moon, stars, rain, and thunder.

Religious beliefs and ceremonies dominated ancient life and inspired most of its art and architecture. To communicate with their gods, people built pyramid-temples that reached toward the skies and imitated the shape and direction of the sacred mountains around them. Mountains and rivers were considered sacred because they were the source of fresh water for drinking and growing crops. Works of art were created as gifts of appreciation for the gods' help in controlling the weather and granting success in farming, hunting, fishing, or waging war.

Using stone, clay, or metal, artists gave the early gods both animal forms (zoomorphic) and human forms (anthropomorphic). Sometimes they combined the two in a fantastic shape. Gods were portrayed according to specific religious laws. Clay objects of gods were especially sacred, because they were made with natural elements: taken from the *earth,* the clay was mixed with *water,* then hardened with *fire.*

Many animals were given god-like status. Most often depicted were jaguars, eagles, serpents, and fish. Because they flew through space, swam the depths of the ocean, and prowled the corners of the earth, these animals seemed closer to cosmic forces than humans. In creating sacred art forms, artists were trying to make visible the invisible forces in their world. Although the names of individual artists usually are not known, many Maya monuments bear the names of their makers.

Perhaps the animal deity of greatest importance was the jaguar, the most powerful and fearful creature of the jungle. By paying homage to the jaguar, the ancient peoples hoped to transfer its power to themselves. Ancient kings and chiefs wore jaguar pelts, headgears made of jaguar heads, and necklaces of jaguar teeth. Many stone thrones were carved in the shape of a double-headed jaguar.

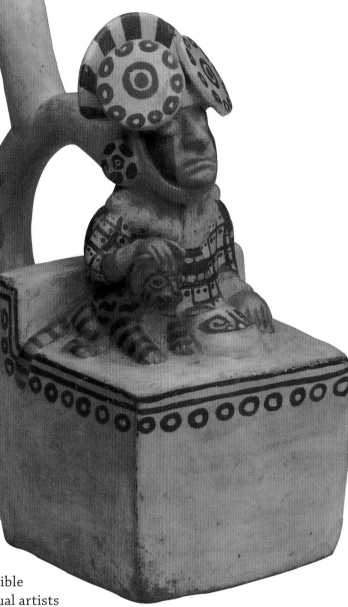

Moche, Vessel Representing Seated Ruler with Pampas Cat
A Moche ruler on his throne wears an elaborate headdress and large spool earrings. He shows his power by resting his hand affectionately on the head of a pampas cat, the fiercest animal in the jungle.

South America, Peru, 400–600 AD. Three-quarters view. Ceramic, 7 3/4" x 7 1/2" (19.4 x 19.1 cm). Kate S. Buckingham Endowment 1955.2281. ©2000 The Art Institute of Chicago. All Rights Reserved.

In Middle America, the Olmecs were the first to introduce the jaguar in stone carvings and sculpture, suggesting it was a divine creature. In South America, the Chavín culture also honored the jaguar, as well as other felines. Both the Olmec and Chavín cultures flourished around the same time. Although they lived far apart, they may have had contact with each other, perhaps by sea.

Tribes that developed later in both regions continued to worship feline gods. In ancient Peru, pampas cats native to the coastal

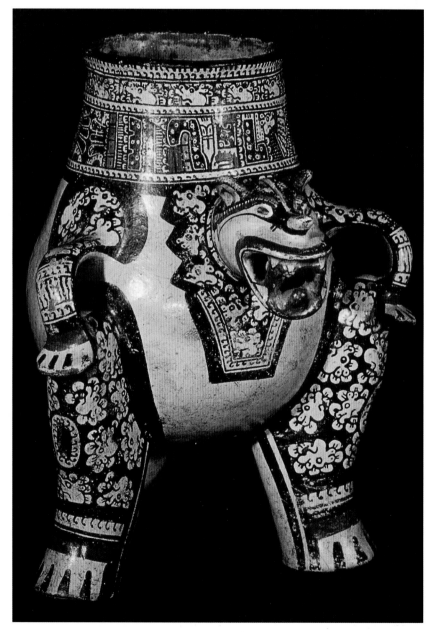

Nicoya, Jaguar Vessel
A ferocious jaguar emerges from the front of a container used in religious ceremonies. The jaguar's curved arms form the vessel's handles, and his rounded forelegs shape two of its legs. Like other early cultures, the Nicoya believed the jaguar had supernatural qualities.

Pacific coast of Costa Rica, 1–500 AD. Ceramic, height: about 14" (35.6 cm). Richard Gray Gallery, Chicago, Illinois. Photo: Davis Art Slides.

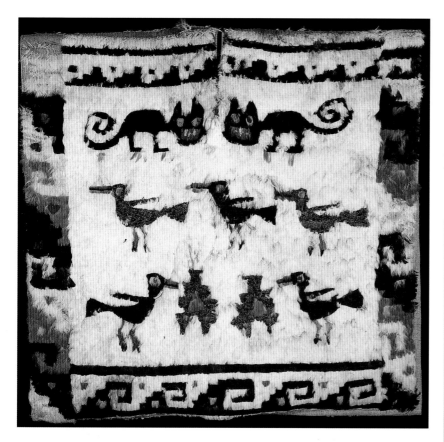

Nazca, Tunic Depicting Felines and Birds
Decorating the poncho are small birds and two black feline deities with glaring eyes and exposed fangs. Nazca feather-workers were skilled in shaping and clipping colored feathers to form a design. Each figure was made by overlapping the feathers and stitching the end of each quill to the woven cloth.

South America, South Coast of Peru, 3rd/4th centuries. Camelid wool, plain weave, embellished by feathers knotted and attached with cotton yarns in overcast stitches, 33 $^1/_4$" x 33 $^3/_4$" (85.2 x 86 cm.) Kate S. Buckingham Endowment, 1955.1789. ©2000 The Art Institute of Chicago. All Rights Reserved.

Huanacaúri
Ancient religious sites are still important to native people today. A modern Peruvian painter expresses the feelings he experiences when visiting Huanacaúri, a hill sacred to his Inca ancestors. He does not paint realistic shapes in this abstract painting, but the two dark mirror images suggest the duality of Indian myths.

Fernando de Szyszlo (Peru; b. 1925), undated. Oil on canvas, 53" x 66" (134.6 x 167.6 cm). The Esso Collection, Lowe Art Museum, University of Miami, Coral Gables, Florida. Photo courtesy Lowe Art Museum.

area were kept for ceremonial purposes. Jaguars were brought as cubs from distant forests.

Many cultures believed in a powerful, human-like creator god who was ruler of the lesser gods. The creator god of the Incas was Viracocha *(veer-ah-KOH-cha),* who was also the sun god and the god of thunder. Inca art often shows Viracocha wearing a headdress of sun rays. On his face are marks that suggest teardrops, which are symbols of rain (see *Gateway of the Sun* on page 50). One legend about him comes from Garcilaso Inca de la Vega, the son of an Inca princess and a Spanish soldier. As a boy, he heard this story from his uncles:

> Viracocha, the sun god, saw uncivilized people living on earth, and sent his son and daughter to teach them to live properly. In exchange, people were to serve him as their god. Viracocha gave his children a long rod of gold to test the ground as they traveled. If the rod sank into the earth with a single blow, that place would become the sacred city of the sun. The brother and sister journeyed far and long. Finally, when they arrived at the valley of Cuzco on a hill called Huanacaúri *(Hwa-na-ca-OO-ree),*

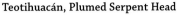
Teotihuacán, Plumed Serpent Head
This stone image of Quetzalcóatl reflects a power and strength the people believed their feathered serpent god possessed. His open jaw, staring eyes, and serpent head contribute to the powerful mood.

Temple of Quetzalcóatl, Mexico, 1st century AD. Stone. Photo: Davis Art Slides.

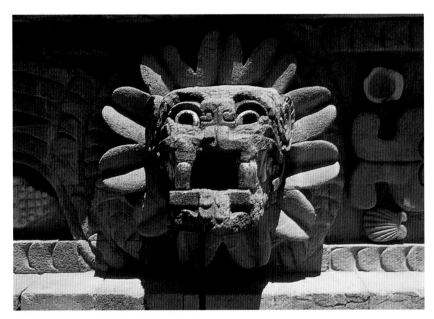

the rod sank into the earth as foretold. The brother and sister won over the people and taught them to be civilized. Thus, the Inca race was born and Cuzco became its sacred city.

Middle Americans believed the creator god destroyed and recreated the world every fifty-two years. The Maya called him Kukulcán *(koo-kool-KAHN)* and the Aztecs called him Quetzalcóatl *(ket-zal-COH- atl)*. Both names mean "feathered serpent." The image of Quetzalcóatl is based on the quetzal bird. The male quetzal is a small, irridescent green bird with a remarkable three-foot-long tail. When this bird is in flight, his tail feathers resemble a wavy snake, giving the bird the appearance of a feathered serpent. (Today these birds are rare, but still live in isolated parts of Middle America.)

Corn was a sacred grain among many cultures. The Maya were known to fill the mouth of a deceased family member with ground corn, believed to feed them in the afterlife. According to an Aztec legend:

Quetzalcóatl created the human race by bringing bones of the dead from the underworld and sprinkling them with his blood. To sustain their lives, he needed maize. He changed himself into a black ant, crawled into a mountain to steal the grain from a red ant, and returned with enough corn to feed the people.

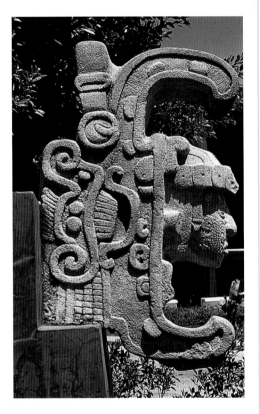

Maya, Priest Emerging from Jaws of Serpent (Sacerdote emergido de boca de serpiente)
Images of a human head emerging from the jaws of a bird or a serpent appear frequently in Maya art. They are associated with the creator god Kukulcán, and the belief in his power.

Uxmal, Mexico, 2nd–10th century. Stone. Modern copy from Cuernavaca, Mexico, De Selva Sculpture Garden (no longer in existence), after original carving from Pyramid of the Magician. Photo: Seymour Chaplik.

The lesser gods had special names, but they were actually the creator gods, who had magical powers to change themselves into other forms. Once cultures developed an agricultural system for their food supply, they depended on the gods of water, corn, and sun for their survival. To insure the gods' good graces, they offered gifts regularly. Some gifts were vessels made in a particular god's image or with related symbols.

The Maya rain god, Chac, is often shown in streams of falling water, with shell earpieces, catfish whiskers, and body scales. Because of its quick-striking movement, the snake (or serpent) was a symbol for lightning. As the god of lightning, Chac is shown with

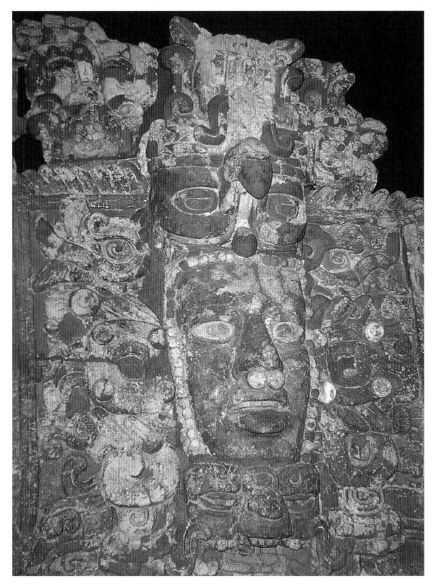

Maya, Sun God (Dios de sol) Kinich Ahau
The Maya sun god is represented by the large, central mask. His role was to give light, create warmth, and make the crops grow. The two smaller masks, one above his face and the other below, represent the fire god. The disk was found in the lower section of the pyramid-temple known as El Castillo.

From Chichén Itzá, Mexico, 8th–9th century. Disk with mosaic of turquoise, shell, and flint. Reproduction authorized by Instituto Nacional de Antropología e Historia, Mexico D.F. Photo: Seymour Chaplik.

reptile features or holding an axe resembling a serpent. Sometimes Chac looks more human, although his nose is usually long and snake-like, ending in an upward curl.

The Aztec water god, Tláloc, also carries lightning bolts that resemble serpents. Aztecs believed that Tláloc controlled the weather from the pyramid-temple dedicated to him at Tenochtitlán. His assistants *(tlaloques)* were said to create rain by striking water-filled pots with sticks.

Family passions are described in an Aztec legend about the moon, sun, and stars. It involves the earth goddess Coatlicue *(koh-*

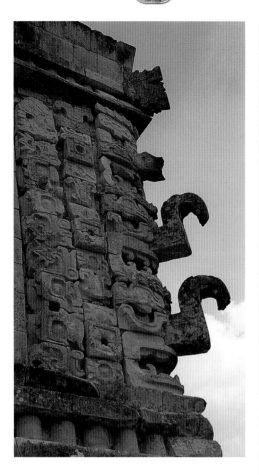

Maya, Chac masks

Chac, god of rain and lightning, is among the oldest deities honored. He is still worshiped today by many Mayans. This carving on the corner of an ancient building shows Chac with a long, curving, snakelike nose, an open mouth, and fierce teeth.

Uxmal, Yucatán, Mexico, 600–800 AD. Stone. Photo: Seymour Chaplik.

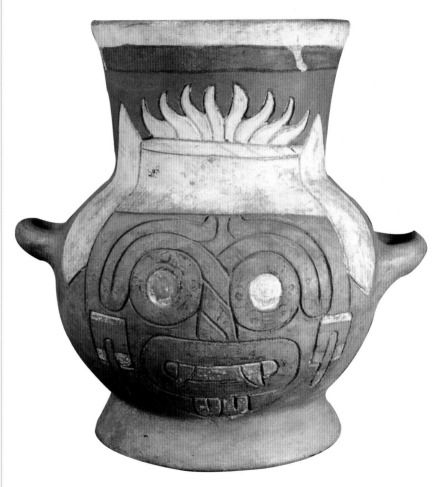

Aztec, Tláloc Vessel (Vasija de Tláloc)

Dedicated to the Aztec rain god Tláloc, this vessel was discovered recently among the ruins of the Great Temple at Tenochtitlán. Notice how Tláloc's prominent eyes are topped by eyebrows that turn and twist like moving serpents, symbols for lightning.

Mexico, Tenochtitlán, 15th century. Ceramic. Height: 12", width: 12 $^1/_2$", depth: 9 $^5/_8$" (30.5 x 31.8 x 24.5 cm). Museo del Templo Mayor. Photo: Frederico Rivera, courtesy of Mexican Fine Arts Center Museum, Chicago Illinois. Reproduction authorized by Instituto Nacional de Antropología e Historia, Mexico D.F.

aht-lee-KWAY), her sons (the stars), and her daughter (the moon goddess). Some scholars believe that the Aztecs reenacted this mythical battle in their rites of sacrifice:

> While sweeping at a sacred mountain, Coatlicue, the earth goddess, becomes pregnant. Her jealous children are furious at her condition and decide to kill her. At the moment of her death, she gives birth to a fully armed son, Huitzilopochtli (*wheat-zeel-oh-POHTCH-tlee*), the god of sun and the god of war. When he rises in the sky as the sun god, he kills the light of the moon and stars. Each day the sun god is reborn in the east and struggles again with the moon and the stars and defeats them.

Another myth about the heavenly bodies comes from the Collas *(COH-yahs),* a tribe conquered by the Inca:

> Before the human race existed, the creator god ordered the sun, the moon, and the stars to ascend to the heavens. Before ascending, the sun took on the form of a brilliant, shining man. He spoke to the ancient pre-Inca people and predicted that someday they and their descendants would conquer many lands and become great rulers. Then the sun, the moon, and the stars arose and took their places in the sky.

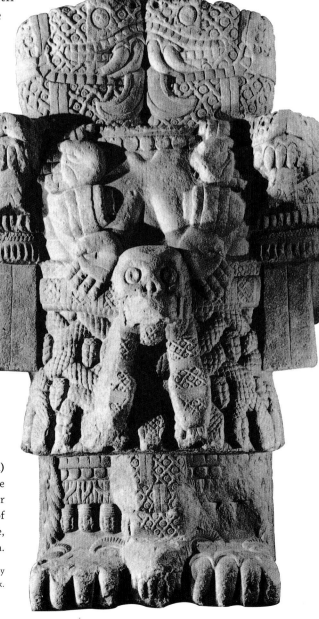

Aztec, Coatlicue, Earth Goddess (Diosa de la tierra)
As goddess of birth and death, and mother of gods and men, Coatlicue represents the duality of human beings. Death symbols hang from her necklace, serpents sprout from her neck, and her skirt is made of intertwined serpents. The snakes are Aztec symbols of earth and time, strength and wisdom.

Mexico, 14th–15th century. Stone. Height: about 8 $^1/_2$' (2.57 m). Reproduction authorized by Instituto Nacional de Antropología e Historia, Mexico D.F. Photo: Seymour Chaplik.

INFLUENCES FROM EUROPE

> The European conquerors perceived the native people as primitive and strange. They were useful as a source of labor, but were not acceptable unless "civilized" by the Europeans.

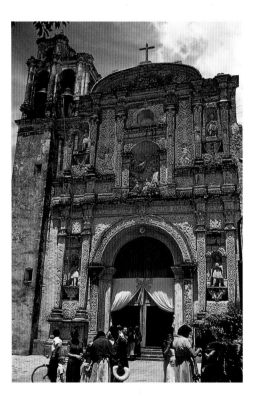

Cathedral of Cuernavaca, East Facade
Using European models, Indian laborers built churches in the new territories and carved indoor and outdoor sculptures. They worked under the supervision of Catholic missionaries.

Cuernavaca, Mexico, 1529. Photo: Davis Art Slides.

AFTER THE FOREIGN CONQUEST of Indian territories, boats arrived from Europe crammed with people eager to claim land in the New World. Among the arriving settlers were shipbuilders, cabinet-makers, and blacksmiths. Farmers came with sugar cane, flowers, fruits, vegetables, and grains never seen before by the Indians. Others brought oxen, chickens, sheep, cats, new breeds of dogs, and horses like those the conquerors rode to victory. (In early battles, the startled Indians thought each armored soldier and the horse he rode was a single creature, and that his sword was lightning.)

Spanish lawyers arrived to establish Spanish law and authority, and to see that the flag of Spain was planted in most of the new territories. New cities were designed according to Spanish plans, and Indians were forced to settle there. Soon European-style hospitals, schools, churches, bridges, and aqueducts appeared across the land, all built by Indian laborers who were instructed by the new ruling class.

Missionaries from the religious orders of the Franciscans, Jesuits, Dominicans, and Augustinians came to convert the Indians to Christianity. They viewed the old Indian beliefs as the work of the devil, and ordered that all pyramid-temples be torn down. All religious objects were to be destroyed. With the new religion came the need for new houses of worship.

As Christian churches went up, monks began teaching the Indians Bible stories and other religious subjects. As teaching tools, missionaries pointed to the figures and symbols carved under their supervision on the walls of the new churches. They also used printed illustrations brought over from Europe to explain important figures. By the middle of the sixteenth century, European artists arrived to work on church art and help train native artists.

Although the Indians copied from European illustrations and were supervised by monks and trained artists, they gave unique Indian traits to church decoration. Instead of the traditional European vines that decorated church walls, they often carved the shapes of tropical flowers and leaves from their own regions. They included images of corn, pineapples, serpents, or feathers.

Native artists frequently asked their neighbors to pose for them, resulting in Christian holy people with Indian faces and

figures. These figures sometimes suggested the powers of the old gods. When painting a landscape, an artist from Mexico's lowlands might include tropical flowers and shrubs, or give an angel the wings of an exotic local bird. A Peruvian artist from the high Andes might fill the corners of a painting with details of his own mountain landscape. This Indianizing of Christian art took place throughout Latin America, but it was especially strong in Cuzco, Peru. The new style that emerged became known as the Cuzco School.

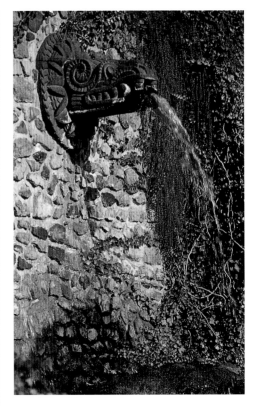

Serpent-head Fountain
Undoubtedly carved by Indian hands, an image of the old feathered-serpent god graces a Christian church in Mexico.

Guadalupe, Mexico, 16th century. Stone, Basilica of Our Lady of Guadalupe. Photo: Davis Art Slides.

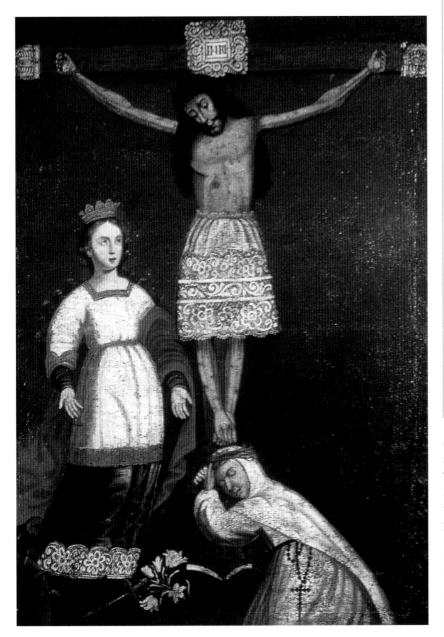

Cuzco School, Lord of the Earthquakes with Saint Catherine of Alexandria and Saint C.
The dying Christ figure wears a lace skirt, suggesting the way important Inca persons once were wrapped in lace before their burial. The painting's subject is based on a terrible earthquake in 1650, which stopped abruptly when a sculptured Christ figure was taken from the church and carried into a procession.

South America, Peru, 17th–18th century. Oil on canvas, 37 $^{1}/_{2}$" x 55 $^{3}/_{4}$" (95.25 x 141.6 cm). New Orleans Museum of Art: Museum purchase. Photo: Davis Art Slides.

Cuzco School, Holy Family (La sagrada familia)
Although modeled after a European painting, the mountain setting resembles the Andean region in Peru. South American birds hover among the trees. On the ground grow delicate Andean flowers.

Peru, 18th century. Oil on canvas, 28" x 35" (71 x 89 cm). New Orleans Museum of Art: Museum purchase through the Ella West Freeman Foundation Matching Fund. Photo: Davis Art Slides.

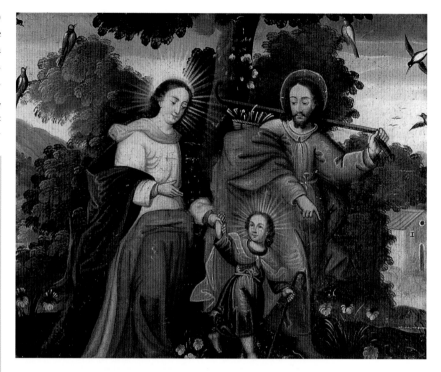

Virgin and Child Crowned (Virgen de Valvanera)
This work of art was created by one of the few colonial painters to achieve prominence. His paintings were known for their decorative quality, as in the jeweled trim of the Madonna's gown and headdress.

Miguel Cabrera (Mexico; 1695–1768), 1762. Oil on copper, 16 9/16" x 12 1/2" (42 x 31.75 cm). Philadelphia Museum of Art: The Robert H. Lamborn Collection. Photo: Graydon Wood.

Painting on linen canvas in the European style was expensive and impractical because the fabric had to be imported from Spain. Instead, colonial artists used native cotton. It was plentiful and when firmly woven, resembled linen. They also avoided the expense of importing linseed oil, traditionally used for blending pigments. By combining oil paints, tempera, and watercolor on the same picture, they could achieve a desired shade.

The colonial period began with the arrival of the church missionaries and continued for about 300 years, until the colonies each declared their independence. Only a few colonial artists achieved prominence, and the names of most are unknown.

As Catholicism became firmly established, countless artists, trained and untrained, were inspired to carve Christian images, often for private devotion in the home. The tradition continues today.

Virgin of Sorrows (Virgen Dolorosa)
The image of the Virgin Mary, introduced by Catholic missionaries after the conquest, is still a much honored figure in Mexico and all of Latin America.

Pepe Hernandez (Mexico, d.o.b. unknown), 1988. Painted papier mâché, height: 25 1/2" (64.8 cm), width at base: 19" (48.3 cm). Collection of William S. Goldman, Chicago, Illinois. Photo: Erin Culton.

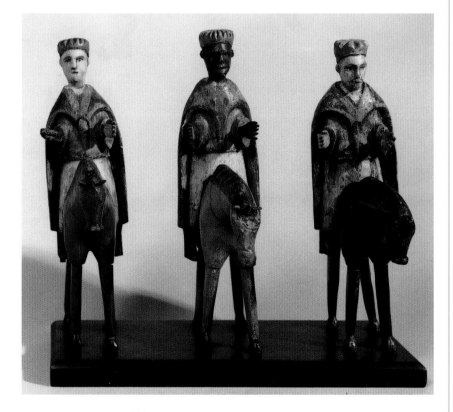

The Three Kings (Los tres reyes)
Christian holy figures like the Three Kings were introduced in colonial times, and since then have inspired religious faith throughout Latin America. Puerto Rican *santos de palo* (saints of wood) are known for their simplicity and beauty.

Artist unknown, late 19th century. Painted wood. Puerto Rico. Collection of El Museo del Barrio, New York. Gift of Dr. Victor de León Hernandez. Photo: Karl Peterson.

PYRAMIDS AND OTHER STONEWORK

Although Egyptian pyramids are older, bigger, and more famous, many early Latin American cultures also built pyramids. These structures were of central importance in most communities, where art, architecture, and worship came together in one form.

THIRTY-FIVE HUNDRED YEARS AGO, the Olmec mother culture set a pattern for architectural planning in Middle America that guided later cultures. The Olmec built pyramids against a background of mountains and sky, to express their profound relationship with nature. Pyramids stood in religious centers, along with carefully grouped administrative buildings, open courtyards, low earthen platforms, and rows of stone columns.

Five hundred years later, about 800 BC, the Maya culture was developing. The Maya also arranged their architecture in harmony with the landscape. Their concern was with the exact placement of the pyramids, rather than the interior space. Even the greatest Maya

Maya, Pyramid-Temple of Inscriptions
A 65-foot-high pyramid supports the Temple of Inscriptions. It is named for three large wall panels inscribed with 620 hieroglyphs which record the dates of historical events. The body of a Maya ruler—wearing a jade mask, rings, and a jade necklace—was once buried in the pyramid's interior.

Palenque, Chiapas, Mexico, 7th century AD.
Photo: Seymour Chaplik.

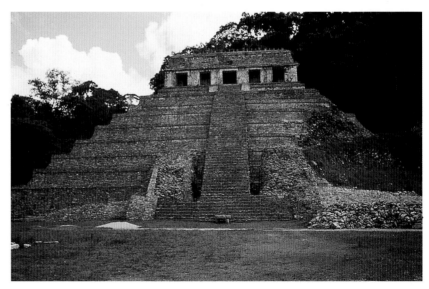

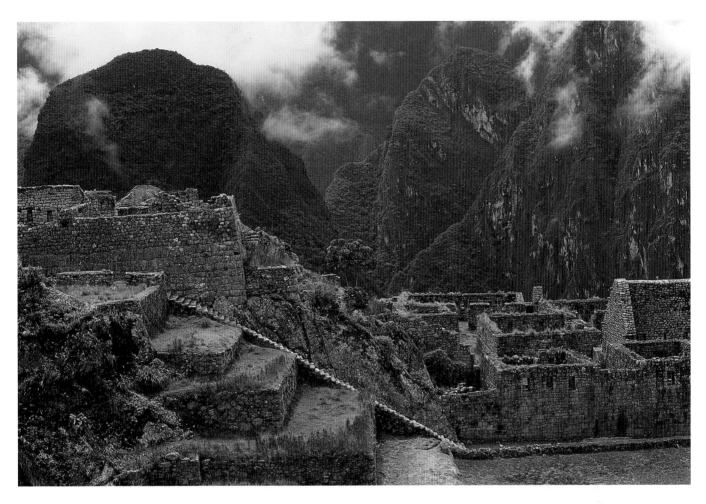

Inca, Machu Picchu

A view of the Inca city of Machu Picchu shows a careful balance of agricultural terraces, architecture, and mountain setting. Original roofs made of natural vegetation have disintegrated. The precision stonework, however, is still standing after many centuries.

Peru, 1400–1532 AD. Photo: Elsa/Rufus Baehr.

pyramids had small, dark interiors. Many held the tombs of ancestors. As the Maya culture advanced across the land, they both influenced and were influenced by other cultures.

Pyramids were solidly built to resist destruction from the elements. The earthen mounds built by the earliest cultures eventually developed into broad-based pyramids made of stone blocks. Middle American pyramids generally had four sides. Stairs were on one side only, leading to a temple at the top which was dedicated to a particular god. Inner and outer pyramid walls were sometimes covered with carved decoration. Later, builders began painting them with vivid colors.

Teotihuacán, Pyramid of the Sun
The shape of the Pyramid of the Sun mimics Cerro Gordo, a nearby sacred mountain. Mountains were sacred because of their closeness to the sky, and because they were the source of fresh water.

Teotihuacán, Mexico, 1st century AD. Photo: Karen Durlach.

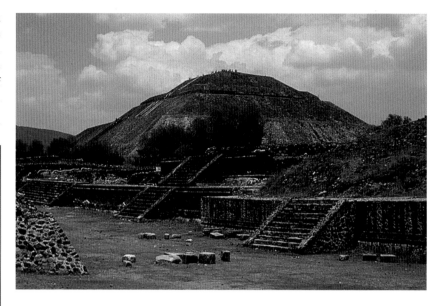

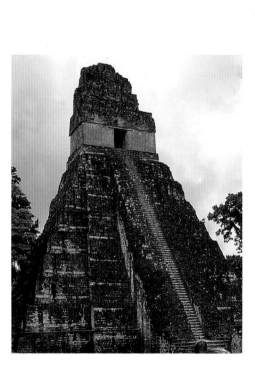

Maya, Temple I
Sometimes called a skyscraper, Temple I is over two hundred feet high. It is one of five tall temple pyramids at Tikal, the largest of the Maya ceremonial sites. Intricate carving decorates the roof comb of Temple I, as well as the wooden lintels above each temple doorway. At every level of the pyramid, carved stucco masks of Maya rulers adorn the walls. At one time the site was in ruins, but today it is fully restored.

Tikal, Guatemala, c. 700. Photo: Davis Art Slides.

The Teotihuacán culture dedicated its pyramids to the feathered serpent god and the gods of the sun and moon. In the sacred city of Teotihuacán, pyramids stood with other religious structures in geometric precision along a great avenue. Known as the Avenue of the Dead, it was about two miles long and fifty yards wide.

At the Aztec capital city of Tenochtitlán, each temple's roof comb—a tall stone structure atop the roof—identified the god honored by the pyramid-temple. For example, the pyramid of Tláloc, god of rain, had a blue roof comb carved with marine symbols such as fish, shells, and waves. Tenochtitlán's Great Temple was dedicated to two gods, so the pyramid had two staircases and two shrines at its summit.

Middle Americans believed that the creator god destroyed and recreated the world every fifty-two years. They celebrated the beginning of each new cycle with religious celebrations that called for erecting new buildings over the old ones. Thus the pyramids grew taller and wider every fifty-two years. The temple at Tenochtitlán actually covered four inner temples. As modern archaeologists cut through levels of later buildings, down to the original Maya pyramid at Uaxactún, in Guatemala, they were reminded of peeling away layers of onion skin.

The ancient landscape was also marked by stone columns, called *stelae* (the plural of stela). Early Olmec columns lacked decoration, but the Maya carved their stelae to record important events. One type of Maya stela portrays a single, elaborately dressed figure. Another type bears glyph writing that records the month, day, and year of an important occasion. Some stelae are carved in low relief. Other reliefs are high enough to project away from the column. The intricate carving is more remarkable when you consider that the artists worked with tools made of stone.

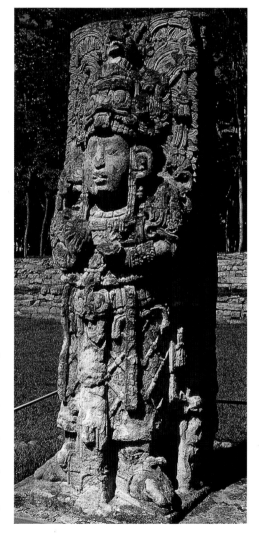

Maya, Stela H, Male Ruler
A ruler wearing the elaborate costume of the corn god stands with feet pointing in opposite directions. His face shows traces of old paint. Glyph writing carved on the back of the stela indicates that the figure is a king named 18 Rabbit.

Copán, Honduras, 8th century AD. Volcanic rock. Photo: Davis Art Slides.

Maya, Stela 3
The Maya ceremonial center at Tikal contains over 200 carved stelae and altars. This one is carved in low relief with hieroglyphic writing. It probably records the exact date of an important event.

Tikal, Guatemala, 8th century. Stone. Photo: Davis Art Slides.

Moche, Pyramid of the Sun

This Moche pyramid was the largest of its type built in the Americas. It once contained 130 million adobe bricks. Now it is less than half its original size. The Spanish invaders eroded one side of the pyramid by redirecting a nearby river. They did this in order to hunt for gold objects stored inside the pyramid.

Peru, 100–700 AD. Adobe. Photo: Edward Ranney.

While Olmec and Maya cultures were thriving, thousands of miles away in South America, the Chavín culture (900 to 200 BC) was also building pyramids. Their religious center in the Andes of Peru was built where rivers, mountain, and sky came together. Now in ruins, the center once contained earthen pyramids, stone columns, low platforms, and a sunken courtyard. Its 35,000 square yards included underground stairways, compartments, and criss-crossing tunnels. While heavy rainfall demolished most other highland architecture, Chavín structures survived many centuries. This was thanks to their extensive drainage systems, good ventilation, and stone-sided pyramids.

Along Peru's dry desert coast, the Nazca and Moche people also set their religious sites near water and mountains. The desert climate helped preserve their structures. The Nazca, on the southern end of the coast, constructed underground canals beneath their adobe pyramid. Individual adobe homes were built away from the religious center, in small groups.

The Moche, to the north, built their Pyramid of the Sun five terraces high across from a sacred hill. The nearby Pyramid of the Moon contained residential quarters, probably for priests and rulers. These rooms were decorated with colorful murals which are now faded.

The capital of the Tiwanaku empire existed in the highlands of present-day Bolivia. An artificial moat surrounded their sacred capital city. A fifty-foot pyramid known as the Acapana was built of earth, gravel, and clay on a great stone foundation. Today only traces of architecture remain. Stone pillars, monuments, and gateways still stand in the midst of eroded soil and slabs of stone.

Inca rulers established their monumental style of architecture in each land they conquered. They built a network of roads throughout Peru connecting the subjugated peoples. Inca builders were known for their skill as stone masons. They constructed buildings by fitting together huge, irregularly shaped stone blocks. Lacking metal tools, they achieved a precise fit by rubbing a stone against the surface of boulders to smooth out bumps and roughness.

At their sacred city of Cuzco, the Inca built palaces and temples surrounded by high stone walls. All this required the labor of thousands of workers. Many stone structures were plastered with natural clay. The finest buildings were brightly painted. In some cases, interior stones were covered with plaques of beaten gold. After the conquest, the Spanish destroyed most Inca architecture by removing the stones to use elsewhere. They kept the foundations to support their own buildings.

Outside the sacred city, the Inca empire needed large public buildings for use as fortresses, housing for armies, and administrative headquarters. The buildings were also used to store tribute goods, or taxes. Conquered people paid taxes in the form of agricultural products, dried meats, animal skins, textiles, and clothing. Later, the goods were redistributed to laborers, soldiers, and others

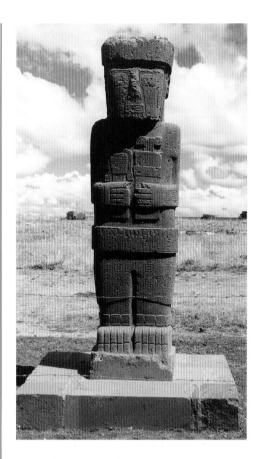

Tiwanaku, Ponce Stela
The figure of an ancient ruler is carved on this stela in low relief. Incised lines on his lower torso indicate he wore body painting. The stela is named after a modern Bolivian archaeologist, Carlos Ponce Sanginés, who discovered the sculpture among the ruins in Tiwanaku.

Bolivia, 400–800 AD. Stone, height: about 10' (3 m), including base. Photo: James Westerman.

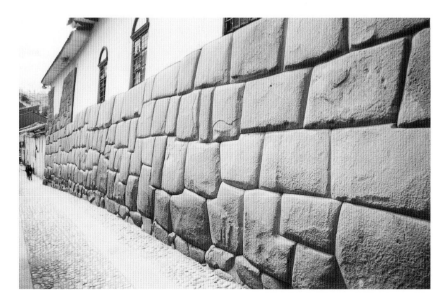

Inca, Stonework
This lower wall is an example of the finest of Inca masonry. Large stone blocks fit together so precisely that even a thin razor blade could not be inserted between the stones. The white stucco upper wall is part of a colonial structure built by the Spanish over the Inca foundation.

Cuzco, Peru. 1400–1532 AD. Photo: James Westerman.

43

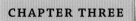

Inca, Ruins of Sacsahuamán

Sacsahuamán (*Sahk-sah-wha-MAHN*) may have been a huge Inca fortress and shrine. Its exact function is not certain. Extending over a third of a mile, it was built of stone boulders. Some weighed as much as ten tons. All that remains today is the foundation.

Cuzco, Peru, 1400–1532 AD. Photo: James Westerman.

who worked for the empire, as well as to those unable to work. Ordinary people were forbidden in Cuzco. They lived in outlying regions, in small, rectangular houses made of adobe or uncut stone set in mud. These were topped by a thatched roof.

Most commoners paid tribute with their labor. Each person owed a certain number of days of work per year. Their labor went into construction of public buildings, strong bridges, and wide roads needed to transport building materials. Today these building sites are in ruins. Inca skill with stone masonry can be seen today, however, in the architecture at Machu Picchu, sometimes called the "lost" city of the Incas. Because of its isolated location high in the Andes, it was unknown until early in the twentieth century. Probably it was never found by the Spanish.

Building a Pyramid-Temple

LOOK AT the pyramid-temples on page 38 and page 40. Both were built by Maya cultures, but they have different shapes. Another pyramid-temple built by Maya-Toltec cultures is on page 48. How are they all similar? They each have steep stair-step sides, a central ramp with easier steps for climbing, and a temple room or building at the top. In this activity you will make your own pyramid-temple out of clay.

1 On a cutting board or plastic tray, roll out slabs of self-hardening clay with a rolling pin. Try to make each slab about 1/2" thick.

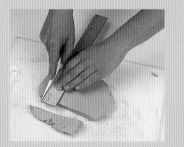

2 Use a ruler and a plastic knife or kitchen knife to cut the slabs into squares. The trick is to cut even squares, each about a 1/2" smaller, on all sides, than the previous square. It might be helpful to measure and cut squares out of paper first and use them as a template, or guide, for cutting the clay squares.

3 Start with the largest square on the bottom and stack the squares on top of each other, like adding layers to a cake. To make them stick together, *score* the clay between layers and add *slip*.

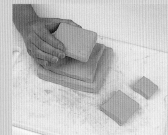

4 Add a ramp on one or more sides and build a temple at the top. Use a plastic knife or other tool to scratch decorations into the sides of the pyramid.

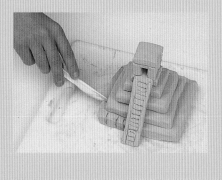

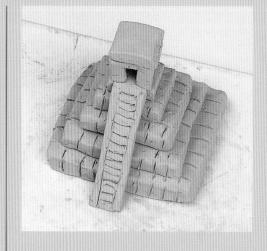

OPTION

When dry, paint your pyramid-temple with brightly colored *slip* or acrylic paint. Dedicate your structure to something special, for instance a person, animal, aspect of nature, or favorite sport or activity. Decorate your building with figures and symbols that give clues to its purpose.

WORDS TO KNOW

score In clay work, artists score grooves or make scratches in surfaces of clay that will be joined together.

slip Clay, thinned with water or vinegar, to form a thick liquid. Slip is used on scored areas to join pieces of clay together. Slip can also be used like paint on leather-hard ware.

PALACES AND HUMBLE HOMES

Depending on time and place, pre-Columbian palaces could be simple in structure, or elaborate and heavily decorated. Family homes might be single dwellings or designed for groups living together.

IN THE CITY OF TEOTIHUACÁN, many ordinary families lived in stone and stucco-carved apartment buildings, near the religious center. When archaeologists first discovered them, they assumed these buildings were palaces because of their brilliant wall paintings and fine architecture. Actual palaces, where priests and rulers lived, were much simpler in construction.

Small Maya palaces recently discovered at Tikal and Uaxactún, in Guatemala, were also modest. Some were roofless, others were topped with straw or palm thatch. In contrast, Maya palaces at Palenque, in Chiapas, Mexico, were elaborately decorated with stucco carvings in high relief.

As archaeologists unearthed the palaces at Tikal, they found limestone archways, known as corbel vaulting. This was a technique for wall-building that used two slanted columns of layered stones. Each jutted out from the wall and supported the stone above. A flat stone at the top connected the two columns and completed the shape of a false arch. Used as early as the first century BC, corbel vaulting enabled the Maya to add windows to their buildings and to connect rooms by making small doorways between them.

Housing for ordinary Maya people was usually simple and practical. After marriage, a man built his own small house. When he needed a larger one, the community helped construct it. Houses were usually rectangular, sometimes round or square. They were built with withes (sturdy twigs) that were covered with adobe and painted in bright colors. Roofs were made of tree trunks and saplings and thatched with palm. Maya homes today are similar in style.

Maya, Corbel Vaulting
Most of this ancient building has crumbled, but a wall with a corbeled arch remains. Arches like these made it possible to create doorways and windows in rooms that otherwise would be dark and airless.

Tulum, Yucatán, Mexico. Stone, c. 13th century. Photo: Karen Durlach

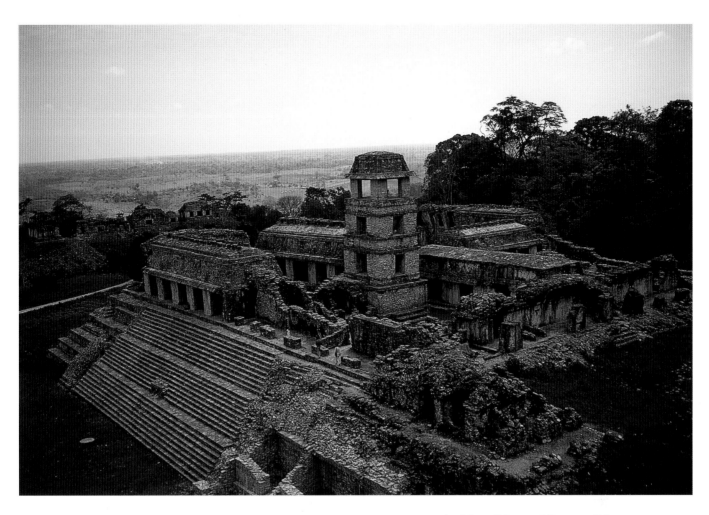

Maya, Palace and Tower at Palenque
The outer walls of this palace were once decorated with colored stucco carvings. The palace contains many rooms with arched doorways arranged around inner courtyards. Can you imagine how the Maya used the square tower in the center?

Chiapas, Mexico, 7th century AD. Photo: Seymour Chaplik.

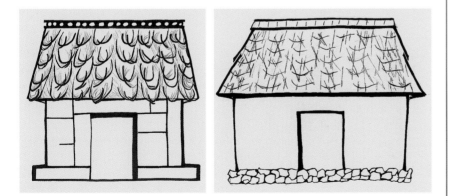

Maya Homes, Then and Now
Early Maya homes (left) were without doors. Copper bells were often suspended from a string and hung across the open doorway. This would give notice to the owners when someone came to visit. Present-day Maya homes are similar to those of ancient times. Both types are built on stone foundations and roofs are thatched with palm leaves.

Drawings by Erin Culton, after A. Beltran (Von Hagen).

OBSERVATORIES AND ASTRONOMY

Like other ancient cultures worldwide, people of pre-Columbian cultures studied the skies. Observing seasonal cycles and changes helped bring order to their lives. Some cultures devised calendars and charted the movements of the stars.

SCHOLARS HAVE LEARNED that studying the stars and planets was important to early peoples in many places of the world. It helped those who farmed to plan times for planting and harvesting. Ancient Americans were avid skywatchers. They observed the position of the stars and the movements of the sun, the moon, and planets. Without powerful glass lenses to aid them, their observations were made with the naked eye. Some relied on pairs of notched, crossed sticks to guide their vision.

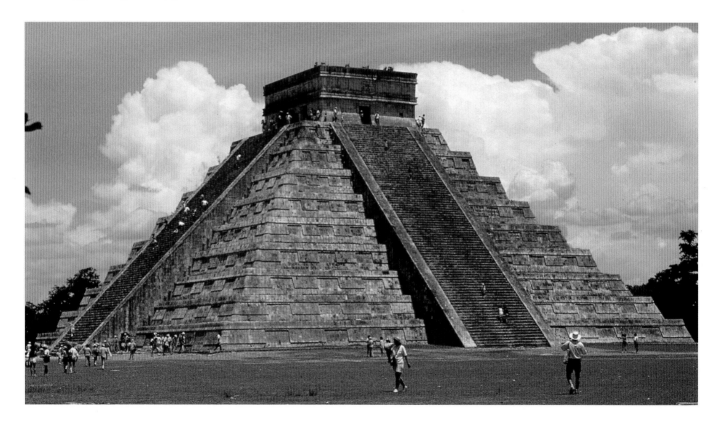

Maya-Toltec, Pyramid of Kukulcán
This Maya-Toltec pyramid is unusual because of its four stairways, one on each side. The four sets of stairs total 364 steps, and the base around the bottom makes 365 steps, which are the number of days in the solar year. This shows the accuracy of the early astronomers and their influence on architecture.

Chichén Itzá, Yucatán, Mexico, 987–1204 AD. Also known as El Castillo (The Castle). Photo: Seymour Chaplik.

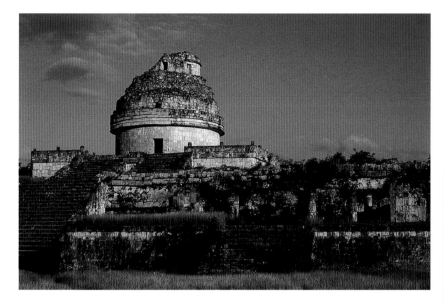

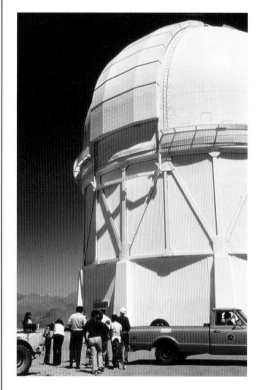

Among the many stargazers in Middle America, the Maya were outstanding astronomers and mathematicians. At Chichén Itzá, Mexico, a circular building served as a Maya observatory. Narrow windows on the upper level gave astronomers a view of the heavens.

From their observatories, astronomers watched the sky and recorded the shifting positions of the celestial bodies. They noticed that during a certain month each year, the sun's position produced the longest day of the year (the summer solstice). During another month, they noted the shortest day (the winter solstice). Twice a year, there was a day and a night of equal length (the equinox). In the northern hemisphere, summer solstice is on June 21 or 22. Winter solstice is on December 21 or 22. In the southern hemisphere, the seasons and the solstices are reversed.

Architects were guided by the mathematics of the astronomers when they designed and built religious centers. At Chichén Itzá, the Pyramid of Kukulcán contains 365 steps, the precise number of days in the solar year. Architects also planned the construction of certain buildings on an exact north-south or east-west axis. This allowed them to catch the reflected light and shadow of the solstice or equinox at a precise time or place, perhaps on a temple, a monument, or a sacred mountain.

Special solar days were celebrated with religious worship, oratory, and chanting. Can you imagine a processional, where priests and ordinary people in special clothing, jewelry, and masks gathered on pyramid steps to observe a solar event? Solar celebrations also announced the time for planting or harvesting crops, and marked the start or end of a fifty-two-year calendar cycle.

Cerro Tololo Stellar Telescope, Main Building
A modern observatory in Chile dwarfs the people standing at its base. Its size and powerful technology gives today's astronomers advantages the ancients never had. Yet ancient cultures collected an impressive amount of accurate information by patient observation.

Cerro Tololo, Chile, 1974. Main Building, Architects: Skidmore, Owings & Merrill LLP. Photograph: Davis Art Slides.

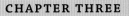
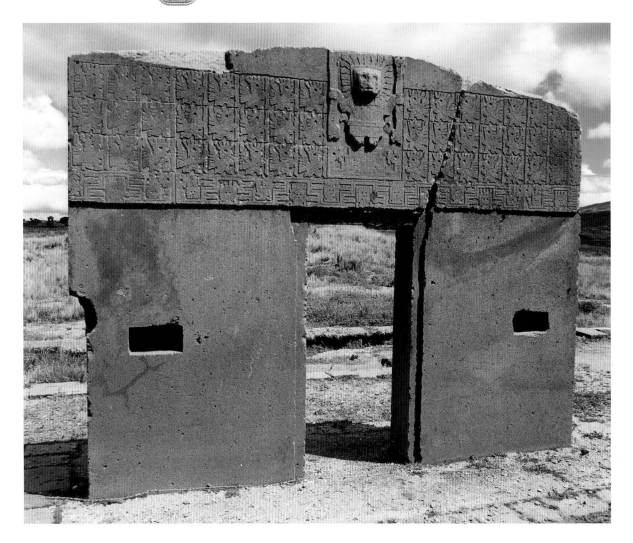

Tiwanaku, Gateway of the Sun

Weighing over ten tons and carved from a single block, the Gateway of the Sun probably stood near the entry of a Tiwanaku temple which today no longer exists. Using astronomy, architects were able to place gateways precisely where the rising and setting sun would be framed during the celebration of certain solar days. The large central figure carved on the gateway represents the Inca creator god Viracocha. He is also known as the sun god and the god of thunder.

Tiwanaku, Bolivia, 400–800 AD. Volcanic rock, height: 10' (3 m), width: 12 $^1/_2$' (3.8 m). Photo: James Westerman.

Like the Middle American cultures, early Peruvian civilizations built their places of worship in harmony with nature. They also had a particular interest in the sun, the moon, and the stars. For example, a ceremonial gateway in the sacred city of Tiwanaku was positioned to frame the rays of the sun on the days of the equinox. Other Tiwanaku doorways offered a daily view of the rising sun. Because ancient Peruvians left no written records, their exact knowledge of astronomy has not yet been clearly defined.

Astronomy may be connected to a group of sand drawings discovered a little more than fifty years ago, in the desert near the town of Nazca, in southern Peru. The drawings have since become known as the Nazca Lines. Marked on the desert sand are enormous figures and lines representing animals, fish, birds, geometric shapes, and anthropomorphic forms, probably deities. However, because of

their giant size, they are impossible to see without distortion, except from the air or from a hillside overlooking the tract.

Some of the straight lines are directed to vital sources of water. Some point to places where the sun rises or sets during a solstice and equinox. This suggests that the lines and figures could be linked to astronomical observations. Perhaps the Nazca attempted to communicate with deities who roamed the heavens and watched over earthly beings. Not all scholars, however, agree with this interpretation.

Drawings on the earth's surface are called geoglyphs. The Nazca Lines were formed by removing the oxidized gravel on the desert surface and exposing the sandy, yellow soil beneath. Geoglyphs have been found elsewhere in Peru, as well as in Chile.

Nazca Lines, Detail

Lines and figures drawn in the sand centuries ago puzzle modern archaeologists. Many lines seem to indicate points of interest in the skies or important bodies of water. Certain figures that resemble deities also decorate Nazca ceramics and textiles.

Aerial view of sand drawings from desert near Nazca, Pampa San José, Peru, 100–700 AD. Photo courtesy Maria Reiche Collection and William J. Veall.

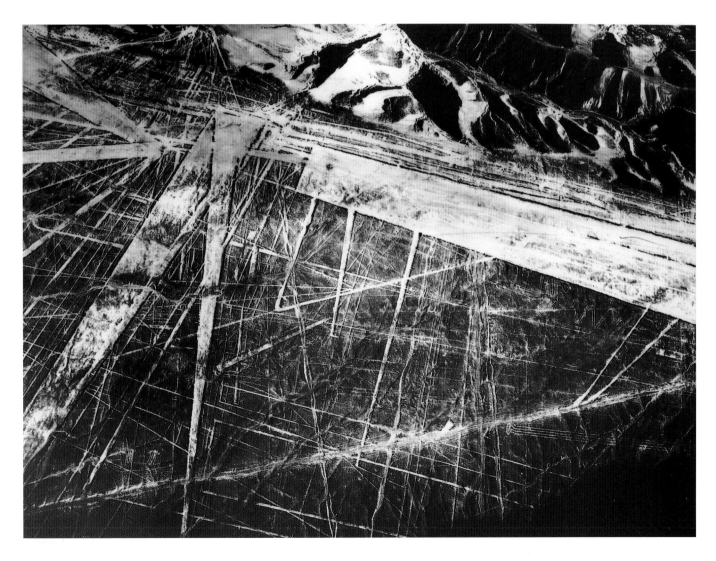

BUILDING CHURCHES

Indian life changed radically with the arrival of the conquerors. Christian missionaries soon arrived from Spain, Portugal, and other European countries.

AFTER THE CONQUEST, the ancient lands were divided into colonies ruled by the Europeans. Towered and steepled churches took the place of pyramids. On first sight, the conquerors had appreciated the well-constructed buildings, magnificent cities, and high mountain roads built by the Inca and Aztec empires. Now they put the Indians to work erecting European-style churches in the new colonies. Often they were built on top of pyramids and palaces that the conquerors ordered destroyed as symbols of an evil, pagan religion.

In Cuzco, the Dominican monks ordered the Inca Temple of the Sun torn down. It was replaced with a large Christian church of dark andesite stone. The stones in the Inca temple had once been covered with plaques of beaten gold. When the Inca ruler Atahuallpa became the prisoner of the Spanish conqueror Pizarro, the Incas removed the gold to pay ransom for his release. Despite their efforts, he was never freed.

Although the new churches were built according to European plans, certain changes had to be made. Because many Latin American regions lie in earthquake zones, church walls had to be thicker than

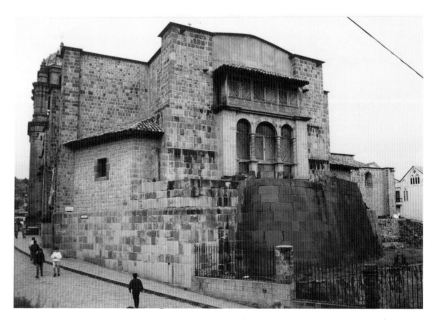

Church and Monastery of Santo Domingo
This church was built on the foundation of the old Inca Temple of the Sun. The Inca stone masonry was earthquake-proof, and gave the church additional height. As other buildings went up in the same way, Cuzco became increasingly tall. Extra roads were needed to reach their doors, creating a city of two levels.

Cuzco, Peru, 16th century. Photo: James Westerman.

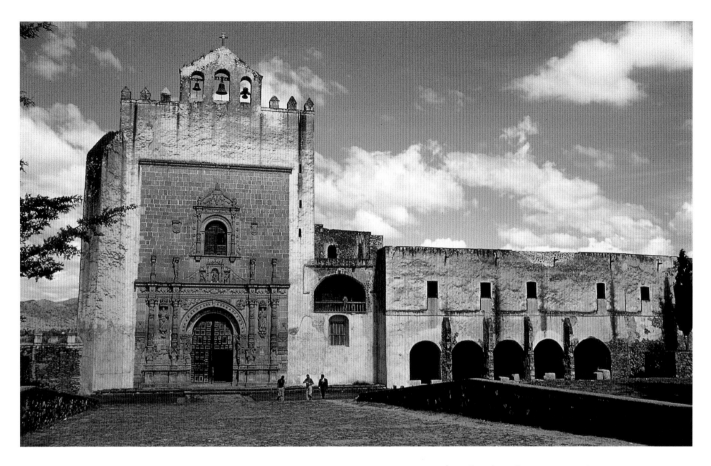

Church and Monastery of San Augustín
This Mexican church was one of the first in Latin America to have open-air chapels. This provided enough space and ventilation for large numbers of worshipers. Because of its balanced facade (front wall) and well-carved decoration, it is considered one of the most beautiful churches built by the Augustine religious order.

Acolman, Mexico, 1539–1560. Photo: Davis Art Slides.

European models and strong enough to resist the tremors. In tropical regions, it was important to accommodate huge Indian populations. So many people could not attend services together no matter how large the church. Roofless chapels were the answer, where great crowds could worship under the open sky with adequate ventilation.

In certain coastal villages in Mexico, pirates and buccaneers were a constant threat. Churches had to be spacious and secure enough to shelter large numbers of people in case of an attack. The solution was to build fortress-churches, like those in medieval Spain and Portugal. Such oversized buildings required large-scale Gothic architecture. European engineers provided the knowledge for building multiple arches and ribs to support the extra weight.

In the Andean mountains, rural churches were barn-shaped with adobe brick walls and a plain stone door. In contrast, church interiors were lavishly decorated with colorful murals and statues, carved columns, and golden grillework. However, early congregations had to stand or kneel on earthen floors. Wealthier ladies would

Arches of Tlalmanalco, Detail
The plateresque (plaster carving) on these arches is considered outstanding among Mexico's open chapels. Notice the human and animal faces and the intricate designs covering the surface of the arches.

From Monastery of San Luis Obispo, Tlalmanalco, Mexico, 1560. Photo: Davis Art Slides.

come to church with a servant who placed a rug on the floor and set a chair for her. By the nineteenth century most village churches had benches and tiled floors.

Churches in large cities were patterned after Italian, German, Spanish, and Portuguese models. As European styles changed, the new lands reflected the revisions. In some regions, churches were heavily ornamented and gilded, in other areas they were kept simple. Style depended on the philosophy of the religious order in charge. Emphasis was on deep interior space, with pillars and arches supporting large domes.

A style of church decoration known as plateresque was introduced from Spain. It had originally developed as carving that decorated sixteenth-century buildings and walls. This carving of stone and plaster was often compared to the fine, small-scale work of the silversmith. Church carvers were sometimes called silversmiths in plaster (*plateros de yeso*). The oldest plateresque church in Latin America, which was also its first cathedral, was built in Santo Domingo, in the Dominican Republic. It was begun in 1512 by the Dominican religious order. The monastery at Tlalmanalco, Mexico, is also known for its outstanding plateresque carving.

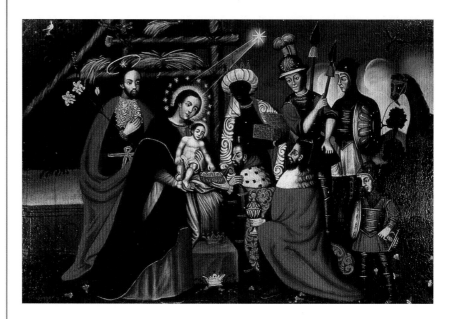

Cuzco School, Adoration of the Magi
The rich colors and textures of religious art, like this Cuzco School painting, contributed to the elaborate baroque style of colonial churches.

Peru, 18th century. Oil, about 28" x 41" (71 x 104 cm). New Orleans Museum of Art: Gift of Mrs. John C. Franklin. Photo: Davis Art Slides.

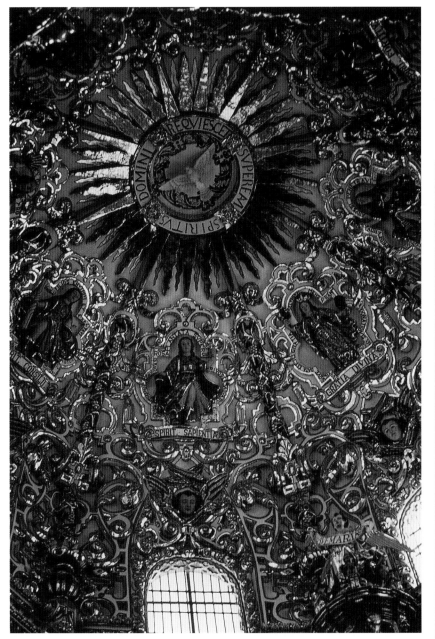

Church of Santo Domingo, Interior of Chapel Cupola

The baroque style is expressed in the elaborate, gilded carving on the domed ceiling (cupola) of this church in Puebla, Mexico. Can you imagine the effect when the ceiling reflects glittering light? The bands of faces and figures circling the dome suggest Indian models.

Puebla, Mexico, 17th century. Photo: Davis Art Slides.

The European baroque style was recreated in the new colonies with dense carvings on church walls, columns, and ceiling beams. The baroque effect was increased by the gold or deeply colored paint of the carvings and the rich tones of the religious art. Carved or painted religious images in the new territories often depicted Indian faces and figures, as well as flowers, birds, and animals from the region.

Church of Bom Jesus
Antonio Francisco Lisbõa, gifted architect and sculptor, designed this church in the native Brazilian style. It includes double towers, a single doorway, and two small windows above the door. Lisbõa carved strong, graceful designs over the doorway and on the pediment between the towers. (This photograph was taken during repairs to the church.)

Antonio Francisco Lisbõa (Brazil, 1738–1814), 1796–1805. Congonhas do Campo, Minas Gerais, Brazil. Photo: Alfred Trott.

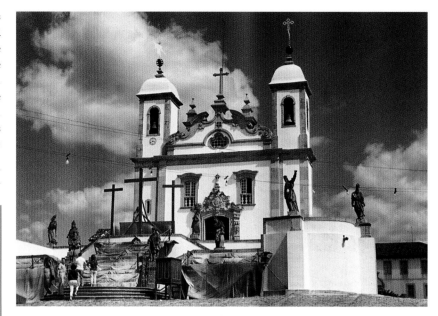

Early Brazilian colonists imitated the massive, heavily gilded style of churches in Portugal, their former homeland. The native Indian laborers who built them had never developed a tradition of creating religious art and architecture. They followed Portuguese plans closely, without Indianizing the churches. When the Portuguese imported African slaves to increase Brazil's labor force, the Afro-mestizo population that emerged made changes in church decoration. Not only did they contribute grace and lightness to the architecture, they also changed some of the decorations. They carved pineapples in place of grape clusters, and herons instead of doves. In time, religious art began to depict African and Afro-mestizo faces.

By the eighteenth century, churches in Brazil were breaking away from European tradition. Churches became taller and more slender, rectangular in plan, with no vaulting or domes. Walls were plastered and painted in light colors, and decorated with delicate and elegant shapes. When gold and diamonds were discovered in the inland state of Minas Gerais, the rush of settlers and an economic boom contributed to a regional style of architecture, more Brazilian than European. Gray soapstone, native to the area, was often used for construction. The soapstone was trimmed with orange sandstone that introduced a warm color contrast.

Among the gifted architects of the time was Antonio Francisco Lisbõa, who was born in 1738. His father was Portuguese and his mother had been an African slave. A sculptor as well as an architect, Lisbõa is known also as Aleijadinho (Little Cripple), because of badly misshapen hands and feet.

The Church of Bom Jesus, in Congonhas do Campo, is considered Aleijadinho's finest achievement. Built on a steep hill, the church includes a walled courtyard containing twelve statues of the Prophets (leaders who spoke through divine inspiration). A path leading to the church includes six small chapels. Each chapel contains painted wood sculptures arranged in a biblical scene.

The Prophet Daniel
Daniel is one of the Twelve Prophets portrayed in the courtyard of the Church of Bom Jesus. The artist, Lisbõa, carved each figure with simplicity and naturalness. The soft texture of soapstone contributed to the flowing lines and intricate designs of the Prophet's robe.

Antonio Francisco Lisbõa, (Brazil, 1738–1814), 1796–1805. Soapstone, Church of Bom Jesus, Congonhas do Campo, Minas Gerais, Brazil. Photo: Alfred Trott.

OTHER EUROPEAN STRUCTURES

Church architecture and religious attitudes affected the style of non-religious city buildings in the new territories. A love of beauty and color was expressed in many different forms of architecture.

PALACES BUILT FOR GOVERNORS and viceroys in the new territories were seldom as lavish as the churches. Many, however, were grand and imposing, with multiple arches and great patios (private court-yards).

Most government palaces and cities were built on Spanish plans. A grid of streets led to the main square, known as the *zócalo*. This central location was bordered by important and solidly built structures, with the church occupying a prominent place. However, not all cities followed the Spanish plan. Colonizers who did not come from Spain built cities that resembled the European region where they were born.

As wealth accumulated, important landowners built fine mansions for themselves. Many chose the plateresque style of the church to adorn their doors or patios. Others chose to use colorful ceramic

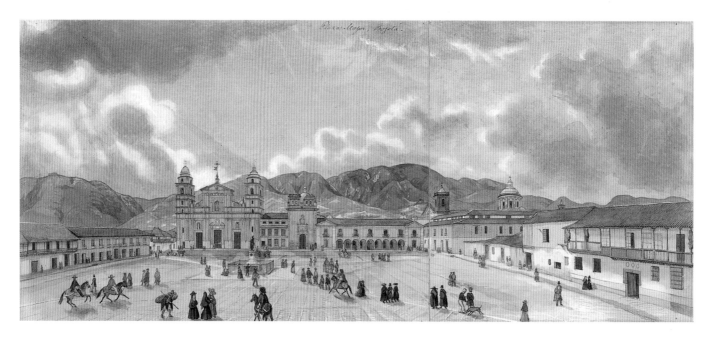

Main Square of Bogotá (Plaza mayor de Bogotá)
Spanish plazas, similar to this one in Colombia, were built throughout Latin America in colonial times. They are still the centers of those cities today.

Edward Walhouse Marck (British, b. Spain; 1817–95), 1846. Watercolor, 15 ³/₄" x 25 ⁵/₈" (40 x 65 cm). Permanent Collection of Banco de la República, Bogotá, Colombia. Registro 057. Photo courtesy Biblioteca "Nuis Angel Arango," Bogotá.

Ceramic Tile
Indian craftsmen quickly learned from the Spanish to paint and glaze ceramic tiles like this one. Tiles were used to decorate church domes and colonial homes.

Mexico, 20th century. Collection of the author. Photo: Davis Art Slides.

tiles like those that decorated church domes, especially in Mexico. Even less wealthy homeowners were quick to beautify their houses, inside and out, with ceramic tiles with floral or geometric designs. Indians were already skilled in working with ceramics, and they easily adapted to the ceramic tiles introduced by the Spanish.

The homes of important men were built as miniature convents, to protect the women from the outside world. Domestic work was confined to an enclosed area at the rear patio of the house. Windows were enclosed with wooden grillework and lattices, and all doors were kept locked and bolted.

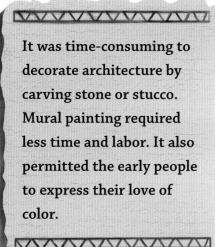

It was time-consuming to decorate architecture by carving stone or stucco. Mural painting required less time and labor. It also permitted the early people to express their love of color.

THE BLUES AND GREENS of the ocean, the white of snow-peaked mountains, and the colors of fire, flowers, fish, and birds surrounded the early peoples. To imitate these rich colors on their walls, Indian artists mixed pigments from animal, mineral, and vegetable sources. Middle American cultures associated certain colors with their gods. For example, the Aztecs used blue to represent Tláloc, their water god. Some colors stood for the four geographic directions (east, west, north, south), or indicated nights or days.

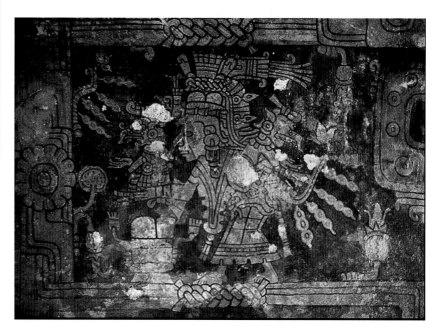

Maya, Section of Mural, Temple of Frescos
Ixchel, goddess of childbirth and fertility, is appealing for rain. She carries two images of Chac, the Maya rain god. Black details on a gray-black background symbolize night and the north, while blue-green coming through the mural's dark paint represents water.

Tulúm, Quintana Roo, Yucatán, Mexico, after 1450 AD.
Photo: Davis Art Slides.

Wall painting often disintegrates after exposure to natural elements. However, at the Mexican pyramid city of Teotihuacán, walls painted over a thousand years ago have retained their original colors. Orange jaguars, red quetzal heads on serpent bodies, and green plumes and masks are still brilliant. On the Teotihuacán murals, the water god Tláloc appears often, surrounded by shells, snails, fish, and picture symbols for rivers and lakes.

Maya murals were concealed for hundreds of years by the jungles of Bonampak, before they were found in 1947. The murals decorate a three-room temple in what is now Chiapas, Mexico. They tell the story of a battle, its aftermath, and the victory celebrations. Although the murals are rich in color, the details have been dimmed by a layer of calcite (dripping mineral-rich water). Copies were made by two artists, who probed the damaged paintings with special materials and used infrared rays to photograph them.

In Peru, murals were found on the interior of Moche pyramids dedicated to the sun and moon. Now faded, the paintings describe warriors in battle, or prisoners taken for sacrifice. The size of each figure varies according to its importance. The person of highest rank is given the greatest height and girth.

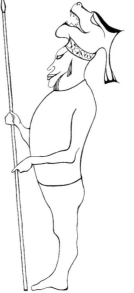

Maya, Detail from a Bonampak Mural
This figure from a ceremonial scene wears fantastic (meaning fanciful, unreal, or strange) animal headgear and carries a tall staff. Notice the natural proportions of this Maya figure.

Chiapas, Mexico, c. 800 AD. Ink drawing by Erin Culton, from photographs and drawings.

Wall painting was a highly developed art in Europe at the time of the conquest. European mural techniques were used to decorate monasteries and churches in the New World.

MURALS AFTER THE CONQUEST

AS DISCUSSED EARLIER, Indians constructed churches and monasteries under the supervision of missionaries. This was also true of murals. At times, important buildings went up on the very spot where the Spanish had fought Indian warriors. As missionaries began to Christianize the Indians, they instructed artists to paint specific battle scenes. In some cases, Indian artists were told to include the miraculous appearance of the Virgin Mary on the battlefield. Other murals showed Bible scenes and the power structure of the church.

Murals of a different nature were discovered recently in a church in Ixmiquilpan, Hidalgo, Mexico. Painted in bright orange and blue tempera, the murals were hidden beneath other paintings. Instead of Christian subjects, the murals depict jaguar warriors and jaguar knights battling dragons and other Indians. They also showed prisoners being captured by the hair. Exactly when the murals were painted is unknown, but no doubt the artist was Indian.

Church murals were usually painted in fresco, with colorful pigments known to the Indians. In addition, the Spanish introduced tempera and oil paint. In monastery cells and cloisters, however, many murals were simple drawings in black or warm gray on white plaster. Images were copied from woodcuts and prayer books.

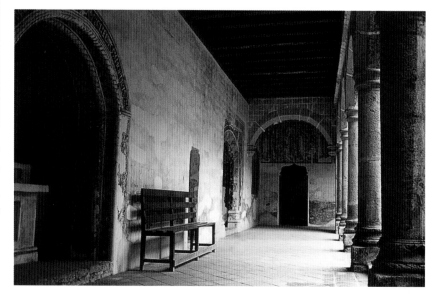

Murals Decorating Ambulatory
The walkway of this monastery is graced with a number of murals from the 1600s. Above the doorway is a painting of the Virgin Mary surrounded by Christian symbols. On either side of the central section, saints are painted on separate, narrow panels.

Cloister of Franciscan Monastery, Huejotzingo, Puebla, Mexico, 17th century. Photo: Davis Art Slides.

62

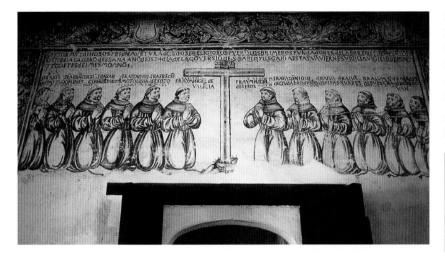

Fresco in Cloister Interior
Inside a monastery meeting hall, a mural shows the twelve Franciscan Apostles kneeling under inscriptions of their names. Above them, a legend describes the arrival of the first Franciscan monks in Mexico.

Franciscan Monastery, Huejotzingo, Puebla, Mexico, 17th century. Photo: Davis Art Slides.

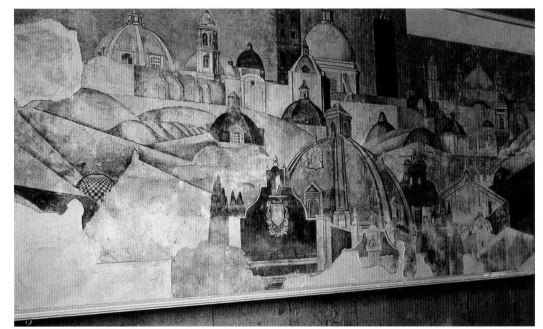

**Architectural View of the City of Puebla
(Vista arquitectónica de la ciudad de Puebla)**
This twentieth-century fresco painting in Mexico shows how the church domes and towers, introduced by the Catholic missionaries, changed the landscape of Latin American cities.

Dr. Atl (Gerardo Murillo) (Mexico, 1885–1964), date unknown. Fresco, 6 ¹/₂' x 18 ¹/₂' (2 x 5.6 meters). Museo Nacional de Historia, Mexico, D.F. Reproduction authorized by the Instituto Nacional de Antropología e Historia. Photo: Davis Art Slides.

By the middle of the sixteenth century, trained European artists working in Mexico formed a guild. It excluded natives from creating religious art, despite their skills. Over a hundred years went by before Indians were allowed to qualify as church artists.

By 1600, authorities discontinued programs to educate and Christianize the Indians. Although they lived in their various villages among their own people, Indians were not allowed to practice their old customs. They were cut off from their cultural roots and missed the nurturing influence of the monks. The authorities often considered them ignorant and inferior. Most Indians lived in poverty, deprived of their pride and dignity.

MURALS IN A TIME OF TRANSITION

> In colonial times in Mexico, mural painting was kept alive by men in the painter's trade, but not as religious art.

AT THE END OF THE SEVENTEENTH CENTURY in Latin America, people began protesting foreign rule and bad government. The movement for independence in Latin America began quietly with protests by students and teachers. Others soon joined them. Indians, Africans, and mestizos formed loose military groups on horseback, led by farmers, students, and sometimes village priests. As they acquired arms and discipline, they became armies.

Soldiers often moved to other countries to help one another win independence. This was the time when great leaders, such as Venezuelan Simon Bolívar and Mexican Miguel Hidalgo, achieved prominence as liberators. Actual fighting went on from 1810 to 1825, although in some places sporadic wars continued to break out after that. The last Latin American battle for independence took place in Cuba, between 1895 and 1898. On the other hand, Brazil won its independence with no warfare or violence in 1822.

During this time, painters were creating murals in homes, shops, restaurants, bath houses, and *pulquerías* (saloons where fermented maguey juice, an alcoholic beverage, was sold). The sole purpose of these murals was to decorate the walls.

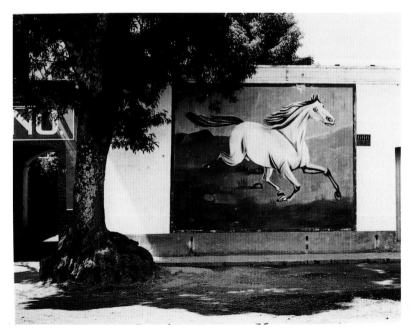

Landscape and Gallop (Paisaje y Galope).
Also known as White Horse.
A photographer came upon a galloping white horse painted by an unknown artist on the wall of a public bath house in the town of San Martín Texmelucan in Puebla, Mexico. The photographer used his camera to create a unique landscape that includes a nearby tree.

Manuel Alvarez Bravo (Mexico; b. 1902), 1932. Gelatin silver print, about 9 ⁵⁄₈" x 7" (24.5 x 18 cm). Restricted gift of Exchange National Bank, 1975.325, The Art Institute of Chicago. All Rights Reserved. With permission of the artist.

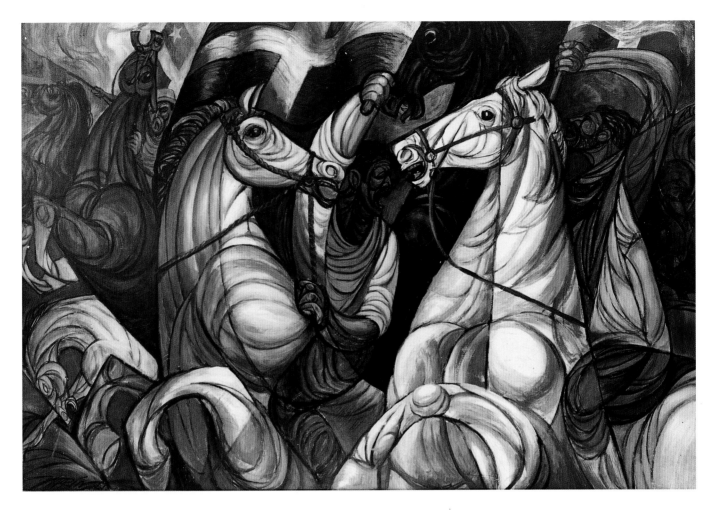

Cry from Lares (Grito de Lares)
A twentieth-century artist imagines the battle for independence that took place in 1868, in the mountain town of Lares, in Puerto Rico. Colonial authorities suppressed the uprising at the time. However, the phrase *Grito de Lares* has come to symbolize Puerto Rican independence.

Augusto Marín (Puerto Rico; b. 1921), 1961. Oil on masonite, 49" x 72" (124.5 x 183 cm). Collection of Instituto de Cultura Puertorriqueña, San Juan, Puerto Rico. Photo courtesy Instituto de Cultura, Puertorriqueña.

TWENTIETH-CENTURY MURALS

Political unrest developed in Mexico at the start of the twentieth century. Artists were ready to carry on the mural tradition as a way of expressing their strong beliefs.

POLITICAL DISCONTENT erupted in the Mexican Revolution of 1910, with the overthrow of a harsh Mexican dictator. A new social and political order was established. The new government leaders called for appreciation of Mexico's rich Indian heritage and promised honor and self-esteem to Indians and mestizos. Mexico's revolution resounded throughout Latin America.

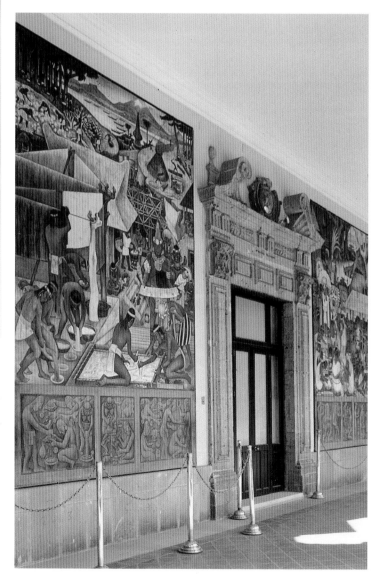

Indians Dying Cloth

Artist Diego Rivera shows ancient Mexicans working in harmony. The Indians pour dyes and hang lengths of freshly colored fabric. Behind them, others work serenely against a background of mountain and water. Rivera studied the ancient picture books (codices) of the Maya before painting this scene.

Diego Rivera (Mexico; 1886–1957), 1945. Mural, Palacio Nacional, Mexico, D.F. ©2000. Reproduction authorized by El Instituto Nacional de Bellas Artes y Literatura; and el Banco de Mexico, Fiduciary in the Trusteeship of the Museos Diego Rivera y Frida Kahlo (Av. 5 de Mayo No. 2, Col. Centro, 06059, Mex. D.F.). Photo: Davis Art Slides.

For some time, Mexican artists had been dissatisfied with official art because of its ties to Europe and to Christian symbolism. They wanted art to emphasize Mexico's natural beauty and the dignity of its own people. Before the war started, artists under art teacher Gerardo Murillo had planned a series of murals to encourage national pride in their Indian background. (Murillo himself changed his name to Dr. Atl, a word meaning water in the Aztec language of Náhuatl.) However, artists had to wait until the violent fighting in Mexico subsided. Then they could safely climb scaffolds to paint public walls.

The first project was at the block-long National Preparatory School in Mexico City. This marked the official start of the mural movement in 1921. Guidelines called for public paintings to be large and heroic in size and realistic in style. Thus, people who could not read could still easily understand historical events. Teams of artists would work together, but each artist would develop his own theme on a different section of the building.

The Conquest (La conquista)

Like his ancient ancestors, artist Orozco expressed his strong feelings on the walls and dome of a place of worship. In this mural, he imagined how the early Indians viewed the Spanish conquerors. With fewer than one thousand men, the Spanish had conquered about four million Indians. To the Indians, Spanish strength and power seemed to come from the horses they rode, animals they had never before seen. This inspired Orozco to paint the armored rider on a monstrous, two-headed horse.

José Clemente Orozco (Mexico, 1883–1949), 1938–39. Fresco, Hospicio Cabañas (Orphanage), Guadalajara, Jalisco, Mexico. ©Clemente V. Orozco. Reproduction authorized by El Instituto Nacional de Bellas Artes y Literatura. Photo: Davis Art Slides.

Three artists who were part of the first team to paint the walls of the National Preparatory School were José Clemente Orozco, Diego Rivera, and David Alfaro Siqueiros. Each later emerged as a giant of the mural movement. Although the movement began as a protest against European religious influences, many of the new murals expressed religion through Christian images.

Despite a strict, Catholic upbringing, José Clemente Orozco often criticized the strong relationship between church and state in Mexico. His first murals expressed that criticism boldly, and caused a mob of students to protest. They threw sticks and stones, rotten eggs, and vegetables at the walls, partially destroying four paintings. Orozco was forced to redo his work. Later he produced murals

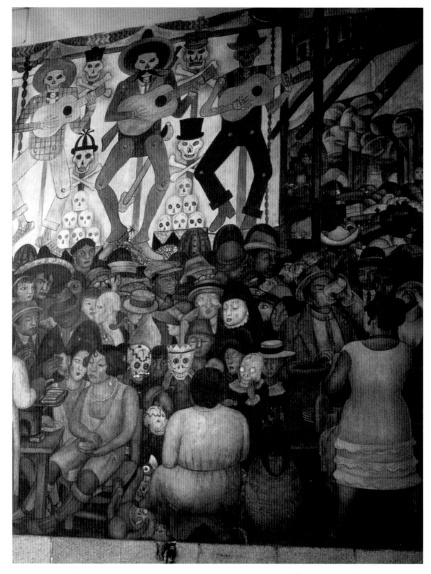

Day of the Dead in the City
Here Rivera paints a scene from the life of Mexicans of his own time, as they observe the annual Day of the Dead. Skulls, crossed bones, and skeleton masks are part of the celebration. The holiday has its roots in the dual theme of life and death, a theme that was emphasized in both ancient Indian times and in Christian rituals.

Diego Rivera (Mexico; 1886–1957), 1923–28. Mural, Ministry of Public Education, Mexico, D.F. ©2000. Reproduction authorized by El Instituto Nacional de Bellas Artes y Literatura; and el Banco de Mexico, Fiduciary in the Trusteeship of the Museos Diego Rivera y Frida Kahlo (Av. 5 de Mayo No. 2, Col. Centro, 06059, Mex. D.F.). Photo: Davis Art Slides.

in many other buildings in Mexico, as well as in the United States. (See mural on page 67.)

At the Ministry of Public Education, Diego Rivera painted frescos with social and political themes related to the revolution. One group of paintings paid tribute to Mexican leaders who had died during the war. Another group illustrated popular songs of the revolution. At the National Palace in Mexico City, Rivera recorded Mexican history from ancient to modern times.

David Alfaro Siqueiros, muralism's third giant, inspired social awareness of the new movement. His murals frequently featured machines and screws to glorify the struggle of laborers. Chains and armor symbolized the bondage enforced by the Spanish conquest.

Cuauhtémoc Reborn: The Torture (Cuauhtémoc Redimido: la tortura)
Cuauhtémoc, the last of the Aztec rulers, was captured and executed by the conqueror Cortés. Artist David Siqueiros shows the Aztec chief undergoing torture through fire. The Spanish wanted him to reveal the location of Aztec gold.

David Alfaro Siqueiros (Mexico; 1896–1974), 1951. Mural, Palacio de Bellas Artes, Mexico. ©David Alfaro Siqueiros/SOMAAP, Mexico, 1999. Reproduction authorized by El Instituto Nacional de Bellas Artes y Literatura.

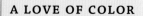
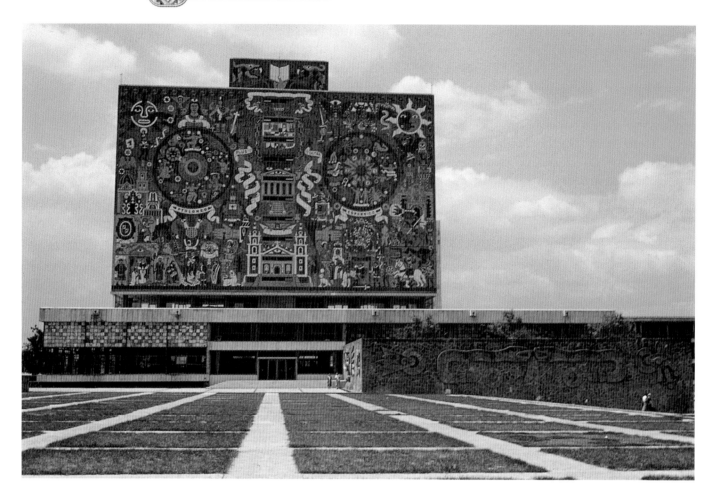

Mural, Executed in Small Stones

Juan O'Gorman's murals are made with colored stones set in cement. Small figures and symbols on each of the four library tower walls illustrate different periods in Mexico's history. The north wall, shown here, portrays the heroes, saints, devils, weapons, and maps of the colonial period.

Juan O'Gorman (Mexico; b. 1905), 1951–53. Library Building, University City, Mexico, D.F. Photo: Davis Art Slides.

Muralism spread quickly through Mexico and across Latin America. The earlier wars of independence had opened the way for a movement to further dignify and liberate the masses. Leading Mexican muralists were invited to share their ideas and skills with other Latin Americans. Working with painters from their host countries, they created murals in Cuba, Puerto Rico, Guatemala, Argentina, and Chile.

Murals were often incorporated in new buildings constructed later in Mexico. Instead of paint, architect Juan O'Gorman used three million colored Mexican stones in the murals he created for the Library Building at the University of Mexico.

TEXTILES

WEAVING IN PRE-COLUMBIAN TIMES was a woman's work. A woman would make garments for herself and her family, as well as ceremonial clothes for use in the temple. Girls learned early to weave and spin, and their status in the community depended on the skill they achieved. Some Inca women were chosen to spend all their time spinning and weaving, instead of helping to plant and harvest crops.

Early in the twentieth century, burial grounds were discovered along the southern coast of Peru. The Paracas culture lived in this region between 700 BC and 200 AD. The dry desert climate had preserved hundreds of funerary bundles containing well-dressed bodies wrapped in expertly woven cloth. Textiles from the Paracas cemetery (Necrópolis) included mantles, poncho shirts, skirts, hats,

> Clues found in murals tell us that textile-making was well known among ancient cultures. Infortunately, fabric decays easily, and examples are scarce or do not exist from many areas of Latin America.

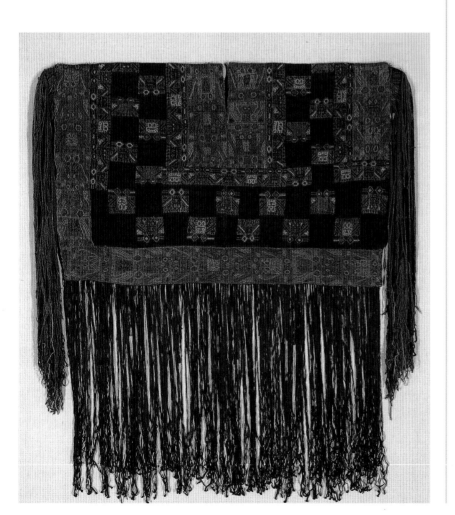

Paracas, Shirt
About 2000 years old, this shirt has the appearance of a garment made in our own times. Discovered in the Paracas burial grounds along the southern coast of Peru, the fabric, embroidery, and color of the shirt were perfectly preserved by the dry desert climate of the region.

Peru, South Coast, c. 300 BC–200 AD. Camelid fiber. Plain weave with embroidery, plain weave with warp substitution. 58" x 29" (147.3 x 73.7 cm). ©The Cleveland Museum of Art, 2000, The Norweb Collection, 1946.227.

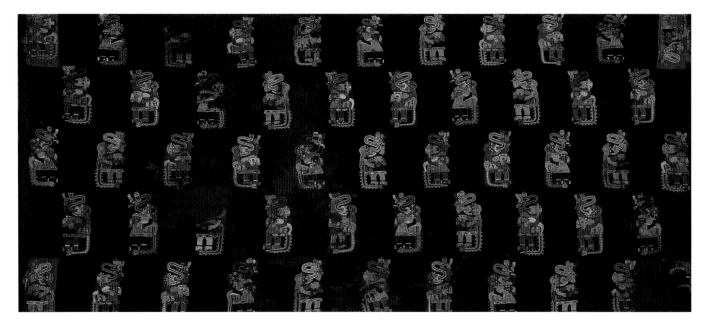

Paracas Necropolis, Mantle

The colorful designs of this mantle (a sleeveless coat or cloak) are set off by the black background. Each embroidered design is similar, with small color differences. The mummies found at the Paracas cemetery were often dressed in several layers of clothing. Ponchos, shirts, and skirts were topped with full-length mantles. Each piece was finely woven.

Peru, 1–200 AD. Wool, plain weave; embroidered in stem stitches; corners edged with plain weave with extended ground weft fringe and embroidered in cross knit loop stitches. 93 5/8" x 42" (238.2 x 106.6 cm). Emily Crane Chadbourne Fund, 1970.293, ©2000 The Art Institute of Chicago. All Rights Reserved.

belts, and bags. These were probably woven during each person's lifetime and set aside to be worn only for burial. Near the bodies of some women were work-baskets containing spindles, balls of cotton, and wool yarn, also for use in afterlife.

The Paracas needed warm clothing in the cold mountain air of highland Peru and in the chill fogs along the coast. These conditions probably encouraged them to excel at weaving. Llamas, alpacas, and vicunas provided them with wool. During leisure between harvesting and planting, people could work out the technical and artistic problems of weaving.

Paracas textiles usually feature figures that combine both animal and human characteristics. Their designs can be complex or simple, sometimes consisting of a single figure, repeated upside down or woven in different colors.

Weaving techniques from Paracas spread to other Peruvian cultures. Each culture added its own variations, but the textiles of every region reflect a love of color. Vegetable dyes for threads and yarns came from roots, bark, and fruits. Animal dyes came from shellfish and insects.

Early fabrics from Middle America have not survived. However, Maya paintings and sculpture show women at their looms. They also show people wearing garments with complicated designs that required weaving skill to produce. Aztec cotton was so fine that early Spaniards thought it was silk.

Handmade textiles are still produced in Latin America today, although factory-made cloth is readily available. Weaving today is often done by men as well as women, on the same types of looms used by their ancestors. The backstrap loom is attached at one end to a pole or tree, while the other end goes around the weaver's waist. The rigid loom consists of a frame set on posts sunk into the earth. Peruvians also use a vertical loom for tapestry weaving, which permits a design in the weave.

When the Spanish arrived, they introduced the foot loom and the spinning wheel. They also brought in new types of thread and yarn, and taught the Indians how to weave sheep's wool.

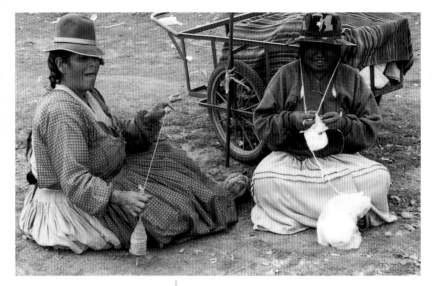

Women Spinning Yarn and Knitting
The handmade textile tradition continues today in Latin America. Here, we see a Bolivian woman spinning yarn, while her companion knits.

Tiwanaku, Bolivia. Photo: James Westerman.

Old Fabric Inserted into New Garment
Old pieces of handwoven fabric from Guatemala were sewn into a twentieth-century jacket made on factory machinery. The brilliant colors of the old fabric give a warm contrast to the geometric design of the new.

Guatemala, old fabric probably late 19th century. Cotton. Collection of author. Photo: Erin Culton.

Machine-made Cotton Fabric
The fabric was woven and printed on modern factory machines in Mexico. The human and animal figures and other symbols printed on the fabric were important to early cultures, and are still valued by Mexicans today.

Mexico, 20th century. Collection of author. Photo: Erin Culton.

STUDIO ACTIVITY

Stamping Designs on Fabric

THROUGHOUT HUMAN HISTORY, people have found ways to decorate cloth. One popular method is stamping designs directly onto the fabric. In modern civilizations, designs are usually printed on by machine. Early cultures, however, would carve designs into wood or other natural materials, and use plant dyes to press designs onto hand-made fabric. In this activity, you will make your own designs to stamp onto fabric.

1 To make printing stamps, cut 3/4-inch-thick slices of potatoes or Styrofoam™.

2 With linoleum-cutting tools, create a shape in your stamp.

3 Brush acrylic paint onto the stamp, and test it first by printing on an extra piece of cloth. For a better impression, place a thick pad of newspapers under the cloth.

4 Make adjustments to your stamp until you are satisfied with the printed design.

5 When you are ready for the final printing, press the stamp hard onto cloth.

OPTIONS

This activity can be done as a class project or an individual project.

• For a class project, begin with a strip of muslin or sheet. It can be dyed before printing or after the prints have dried. For a result similar to the cloth on page 74, each student would press their design onto the cloth using black acrylic paint. A border could be added around each print. For variety, each student could use a different color. The result can be hung in the classroom or school hallways.

• For individual projects, students can work on their own fabric, any size, repeating the original design in a variety of ways and colors. Or, they can cut and print several stamps of their own. A long strip of decorated fabric could be worn as a scarf.

• When printing on paper, block-print ink or tempera paint can be used.

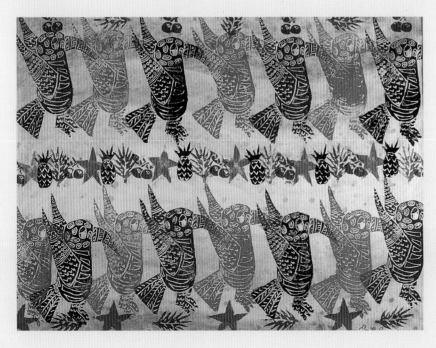

Dancing Parrots
Parrots and other jungle creatures show up frequently in Latin American art. What makes these parrots look like they are dancing? What has the artist done to add variety to her printmaking?

Emily Carr, 1997. Watercolor, ink, 18" x 24" (46 x 61 cm). Turkey Hill Middle School, Lunenburg, Massachusetts.

METALWORK AND JEWELRY

THE ANCIENT CULTURES learned early to work copper, silver, and gold, and often combined two metals to form an alloy. Gold was favored because it was simple to work, easily panned in river beds, and found in a pure state. Silver was often found in an impure state. Copper, due to its hardness, was difficult to mine and to work. Gold was not only easy to handle, it was seen by many as a sacred symbol of power associated with the sun.

Ica, Ear Plug Front
These delicate birds are from a pair of earspool ornaments that were probably worn by a young Peruvian warrior of Ica times. It was the custom among most of the early cultures for both men and women to pierce ears. Then "plugs", with ornaments attached, could be worn.

South America, Peru, pre-Inca, 1200–1500 AD. Gold with garnet inlay, 1 3/4" x 1 1/6" (4.6 x 3 cm). Kate S. Buckingham Endowment, 1955.2594a, photograph by Robert Hashimoto, ©2000 The Art Institute of Chicago. All Rights Reserved.

Diquís Style, Lobster Pendant

A lobster wearing an ornamental headdress was cast by the lost-wax method. Costa Rican goldsmiths were skilled in casting techniques, and their forms included many water creatures. The Disquís region is in southern Costa Rica, close to the Panama border. It is often difficult to know whether gold objects were made in Costa Rica or in Panama, because they are so similar.

Southern Costa Rica, (Diquís Region), c. 1000–1550. Cast and hammered gold, about 3 1/4" x 2 1/4" (8.3 x 5.8 cm). ©2000 The Cleveland Museum of Art, James Albert Ford Memorial Fund, 1943.290.

Sicán, Beaker

Ancient noblemen in Peru used beakers for ceremonial toasting and drinking maize beer. This cup probably accompanied its owner to his grave. It would have been filled with food or beverage for his afterlife. Little is known about the Sicán culture, which emerged when the Moche culture declined. Their gold objects are similar to works by the Chimú, a culture that flourished between 1000 to 1470 AD.

Peru, North Coast, c. 800–1370 AD. Hammered and embossed gold alloy, about 6" x 4 5/8" (15.2 x 12 cm). ©2000 The Cleveland Museum of Art, Gift of James C. Gruener in memory of his wife, Florence Crowell Gruener, 1983.189.

The earliest known gold pieces were made by Chavín artisans in ancient Peru. They shaped gold nuggets by hammering and grinding with stone tools. "Cold hammering" caused the gold to become brittle, and it often broke under the strain. When goldsmiths learned to heat gold, known as annealing, they could soften the metal and hammer it long enough to produce thin sheets of gold. They enriched the gold with repoussé, a design pounded into relief from the reverse side. Headdresses, beakers, earspools, and other ornaments were made from this process.

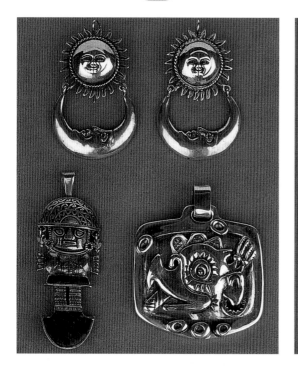

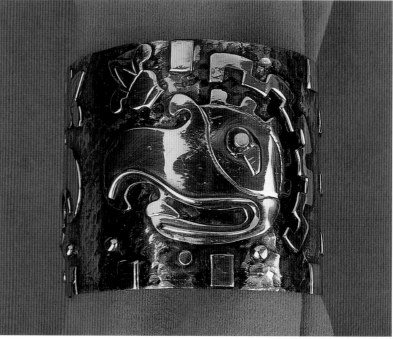

Modern Jewelry

Following old traditions, modern jewelry-makers create images important to the early peoples. The head of the serpent-bird god, Quetzalcóatl, appears on the Mexican bracelet and pendant, while symbols of the sun and moon adorn the earrings. The Peruvian pendant is in the shape of an ancient ceremonial dagger. The figure on the handle is probably an honored leader or hero.

Bracelet (Mexico), silver and copper. Bird's head pendant and earrings (Mexico), silver. Ceremonial knife (Peru), silver and jade. All items between 2" to 2 1/2" (5–6.5 cm) high. Collection of Mari Fohrman, Chicago, Illinois. Photo: Davis Art Slides.

Goldworking spread through ancient Peru and Middle America. Eventually the lost-wax process was developed. In the lost-wax process, an exact model is made from wax. Then a clay mold is built around it. When the mold is heated, the wax melts and drains out (is "lost"), leaving a cavity. Goldsmiths poured liquid gold into the cavity, which took on the shape of the original wax model. Goldsmiths in Panama, Costa Rica, and Central Mexico, as well as Peruvian artists, were especially skillful in producing small ornaments made by this technique.

Both the Inca and the Aztec empires kept storehouses filled with gold objects collected from their subjects as taxes or tribute payments. When European conquerors demanded gold as ransom for their captured leaders, it was readily available. The Spaniards did not realize the workmanship of the objects was more valuable than the gold itself. They melted down all gold into bars, distributed the bars among themselves, and sent a portion to Spain for the king's treasury.

Most ancient gold objects existing today were found in graves, buried with the dead. More objects would be available if grave robbers had not stolen them over the years. In 1987, in northern Peru, the untouched tomb of a Moche priest or nobleman was discovered. The dead man wore gold and turquoise bracelets and copper sandals, and a sheet of gold encircled his head. Around him lay jewelry of gold, silver, and turquoise.

MASKS

CAN YOU IMAGINE the excitement of putting on a mask that changes your personality or gives you supernatural powers? In pre-Columbian times, the wearer of a mask took on its identity and became an animal, a god, or a mythical being with magical powers. Today, many Indian tribes continue to make and use masks as their ancestors did. In northern Argentina, the Chane Arawak Indians wear warrior masks during agricultural rituals, to ensure good planting and harvesting conditions. In Guerrero, Mexico, certain tribes follow an old Aztec custom to bring the rain. Men dress in jaguar costumes and heavy leather masks, and fight each other with whips.

In ancient times, masks were made for religious purposes. Often masks were placed in tombs to cover the faces of important people at death.

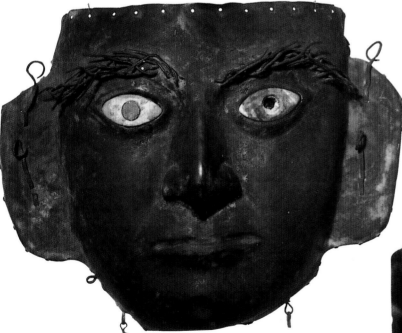

Moche, Mask
This mask was made for burial and was probably attached to a mummy bundle. Because the mask is in the image of an important Moche war god, it is likely that the deceased was a warrior. Originally the mask had shell teeth, now missing, as well as eyes of shell.

South America, Peru, 400–600 AD. Hammered copper with encrusted shell eyes, height: about 7 7/8" (20 cm). Gift of Mr. and Mrs. Nathan Cummings, 1960.900, ©2000 The Art Institute of Chicago. All Rights Reserved.

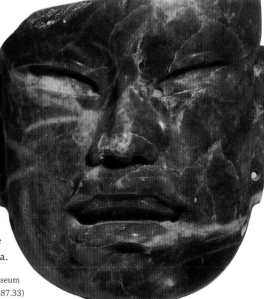

Olmec, Mask
This ancient jade mask describes how Olmec people looked. Like many sculptured Olmec pieces, the mask's full mouth, downturned corners of the lips, and slanted eyes suggest these people came originally from Asia.

Mexico, 18th–10th century BC. Jade, 6 3/4" x 6 1/2" (14.5 x 14 cm). The Metropolitan Museum of Art, Bequest of Alice K. Bache, 1977. (1977.187.33)

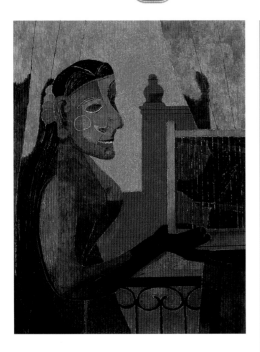

Woman with Birdcage

A modern artist pays tribute to his ancestors by painting a modern Mexican woman with a masked face. Her darkened arm is a reminder of the racial mix of present-day Mexicans.

Rufino Tamayo (Mexico, 1899–1991), 1941. Oil on canvas, 43 $^1/_4$" x 33 $^1/_4$" (109.8 x 84.5 cm). Gift of the Joseph Winterbotham Collection, 1942.57, courtesy The Art Institute of Chicago. All Rights Reserved. Reproduction authorized by the heirs of the artist in support of the Fundación Olga y Rufino Tamayo, A.C.

Separate Indian communities today often celebrate ancient festivals together, with everyone dressed in costumes and masks. The strong, magical meaning of masks helps hold together tribes that value the old traditions.

In towns and cities where the population is mixed, events from today's Catholic calendar are celebrated with masks and ancient Indian rituals. Being comfortable with two sets of beliefs stems from pre-Columbian life, when important deities often possessed two opposite powers. When they were introduced to Christianity, many Indians gave their old gods the names of Catholic saints.

Masks for modern festivals most often are made of wood but also are fashioned from clay, paper, cloth, metal, gourds, and wax. Sometimes the woodcarver works quickly, gouging the wood in a simple, primitive style. At other times the carver is slow and patient, working over a long period of time. Color is usually vivid, applied with commercial house paint or natural dyes. A final layer of lacquer is often applied. Other times, color is subdued and shows the natural tone of the material used. Devil masks may use real horns and teeth, and tiger masks may have real whiskers and actual, fierce-looking teeth. Some masks have glass eyes that open and shut with the pull of a thread, and others have movable jaws. Not all masks are worn over the face. Some may be carried high on a stick, while other masks are made purely for decoration.

Mexican Mask

The mask's bright colors and rhythmic bird and flower designs are typical of certain types of Mexican folk art from Oaxaca. The mask was meant to hang on a wall as decoration, and was probably never worn.

Oaxaca, Mexico, 20th century. Painted ceramic, 9" x 7" (23 x 18 cm). Collection of the author. Photo: Erin Culton.

STUDIO ACTIVITY

Creating a Festival of Masks

LOOK AT the masks on pages 79 and 80. How are they similar to one another? How are they different? Are any of the facial features exaggerated or distorted? What does each facial expression tell you about the personality of the mask? In this activity, you will create a mask that emphasizes a quality that you have or would like to have. For example, if you are fierce, you could make large teeth on your mask. If you wish, choose an animal that you identify with, and create an animal mask.

1 Start with a brown paper bag of any size that will fit over your head. Put the bag on, close your eyes, and gently press with your hands to locate where the eye-holes should be. Use a crayon to mark the spot (a classmate can help).

2 Sketch some ideas on scrap paper, then draw a face on your bag. Make the drawing as large as life or larger for emphasis. Use crayons, markers, or vivid tempera colors to fill in the details.

OPTIONS

- Bags can be cut, pinched, tied, partially stuffed, or taped to change the basic shape.

- You can cut shapes out of colored paper, cloth, or ribbon and add them to your mask. Paper can be curled, folded, or twisted for different effects.

- Items like ears or a long nose can be reinforced with wire or heavier cardboard. Attach them to the mask using glue, tape, or staples.

- Exhibit the masks together in a harmonious arrangement to suggest a festival of masks. Use glue to mount your painted bag on a stick. Use sticks of varying lengths, between one foot and five feet long, so that masks will stand at different heights when completed. Either glue the stick to a wooden base, or immerse it in a can of sand. Decorate the stick and base to suit the meaning of the mask.

Bag Faces
Like his early ancestors, this modern artist uses materials around him to create works of art. Working with brown paper bags, Ferrer has painted faces resembling ancient masks. The masks are supported by wooden sticks on pedestals.

Rafael Ferrer (Puerto Rico; b. 1933), c. 1970. Oil crayon on paper and wood. Photo: Frumkin and Struve Gallery. Reproduction courtesy of the artist.

MUSIC AND DANCE

PRE-COLUMBIAN PAINTINGS and ceramics describe trumpets, flutes, reed pipes, drums, rattles, and whistles that accompanied singers and dancers in elaborate masks and costumes. Some musical artifacts, made from clay, have been found. In addition, Maya murals painted in 800 AD at Bonampak, Chiapas, Mexico, show musicians playing their instruments and dancers performing in spectacular headdresses to celebrate successful warfare.

Ancient agricultural customs were also accompanied by dance and music. Today, Indian groups in certain areas of Guatemala follow the same customs when they plant, cultivate, and harvest corn. They offer special songs and dance rituals throughout the growing season.

Moche (or Mochica), Trumpet
The head of a jaguar decorates the bell of this trumpet. Ceramic trumpets and other musical instruments have often been discovered in ancient burial grounds, filled with soil from the graves where they were found.

South America, Peru, Chimbote, Santa valley, 400 AD. Ceramic, 7" x 11" (17.8 x 27.9 cm).
Gift of Mr. Nathan Cummings, 1956.345, © 2000 The Art Institute of Chicago.
All Rights Reserved.

Besides ceremonial use, the Incas prescribed music for healing certain illnesses, along with herbs and other kinds of treatment. They believed no cure would be successful without the proper music. The music was usually played on a small wooden flute known as the *quena*.

After the conquest, missionaries took advantage of Indian talent in music. To teach the Indians Christian prayers, they set the prayers to simple musical chants. They trained native choirs to sing in voice parts (soprano, alto, tenor, bass) accompanied by an orchestra. The Spanish had come with stringed instruments, such as the harp, guitar, and violin. These were added to the percussion and wind instruments familiar to the Indians. Often, the Indians added dances to special celebrations, and transformed their native steps into European movements.

Colima, Flute Player

Music was an essential part of early ceremonies. An ancient Mexican legend tells how the wind god journeyed to the sun and brought musicians back to earth to delight the souls of men. The Colima people made a variety of hollow clay figures that were as natural and lifelike as this musician.

West Coast Mexico, 100 BC to 250 AD. Ceramic, 13" x 6.5" x 3" (33 x 16.5 x 7.6 cm). Photo courtesy of Douglas Dawson Gallery, Chicago.

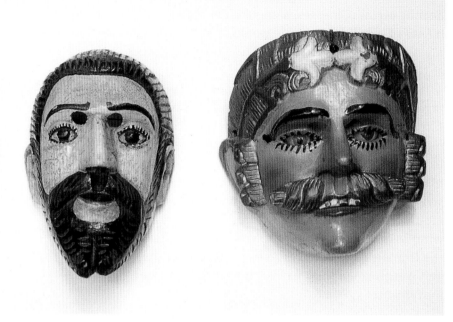

Dance Masks

A favorite dance in most Latin American countries uses masks to reenact scenes of the conquest. Masks and costumes are rented by festival dancers. The dark mask in this set portrays a Mexican character. A person representing an Indian or Spanish character would wear the bearded mask. It has two holes above the eyes to see through. The blue-eyed, golden-haired mask is for the role of a Spanish cowboy *(vaquero)*.

Guatemala, 20th century. Wood, height: about 10" (25.4 cm). Collection of William S. Goldman, Chicago, Illinois. Photo: Erin Culton.

The early fusion of Indian and Christian cultures continues today. Catholic holidays in Latin America are celebrated with ancient Indian dance festivals. Through music and dance, costume and mask, the past and the present are bound together.

In Guatemala, unique organizations, called *morerias,* rent masks and costumes to local dance groups. They usually buy unpainted wood masks from a carver, then paint and repaint them as needed. Animal skins and other types of costumes that cover the dancer's body are often attached to the mask. Masks may last for only a few ceremonies or endure for generations. When a mask is worn for a festival dance, the wearer takes on its character and power, just as people in pre-Columbian times were transformed by wearing a headdress in the form of a deity.

Dances are also based on events from later history. A favorite dance in most countries reenacts scenes of the conquest that occurred in their region. Over sixty versions of this drama exist in Guatemala alone. Dancers wear masks and costumes to represent Indian leaders engaged in battle with Spanish invaders on horseback. The characters do not always exchange dialog, but follow well-rehearsed dance steps. In other dances, dialog may play a large part.

ANIMAL IMAGERY

JAGUARS AND OTHER FELINES, eagles, condors, and serpents were considered among the most powerful creatures of their species. They were associated with important gods and rulers, as discussed in chapter two. Priests, warriors, and leaders would transform themselves during certain ceremonies by wearing animal headdresses and costumes. They would then feel powerful enough to control the forces of nature. In a further attempt to ward off any evil forces, they offered gifts to the gods, in the form of important animals modeled in clay, wood, or metal. At times, they sacrificed the actual animals.

Because they lived close to nature, early people felt a brotherly bond with animals. They saw animals as having human traits, both good and evil. Some were sacrificed to the gods, and others were used to foretell the future.

Moche, Stirrup Spout Vessel with Bird and Feline
By depicting a puma on the back of a condor, the ancient Moche artist combined two of the most powerful creatures known to the early people. These images were symbols of their most important gods.

South America, Peru, 100–200 AD. Smoked grayware, height: 7 1/$_2$" (19.1 cm), length: 8 1/$_2$" (21.6 cm). Gift of Mr. and Mrs. James W. Alsdorf, 1957.103.
©2000 The Art Institute of Chicago. All Rights Reserved.

Colima, Standing Dog

The Colima people produced many clay versions of the smooth, hairless *techichi* dogs. They are sometimes shown sleeping, seated, or dancing in pairs. Dog-shaped vessels were often placed in graves to guide the dead to the next world.

West Coast Mexico, 100 BC to 250 AD. Ceramic, 10" x 19" x 6 ¹/₂" (25.4 x 48.2 x 16.5 cm). Photo courtesy of Douglas Dawson Gallery, Chicago, Illinois.

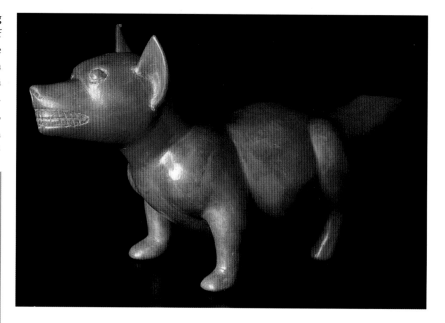

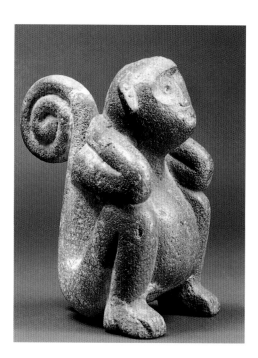

Aztec, Monkey

This Aztec stone monkey appears almost human in its expression and the position of its arms. Capuchin monkeys in ancient times were very friendly. They were skilled with their hands and often adopted as pets.

Central Mexico, Tacuba, 1200–1519. Stone, 9 ⁵/₈" x 9 ³/₈" (24.5 x 23.6 cm). ©2000 The Cleveland Museum of Art, Gift of William Ellery Greene, 1959.125.

Images representing the lesser gods, such as llamas, monkeys, dogs, and spiders, were also offered. In western Mexico, the dog is the most frequently depicted of these animals. The Colima people used the *techichi*, a smooth hairless dog, for food. The dog is also a symbol of death. Its image is frequently found in ancient graves, usually in the shape of a hollow vessel with a spout opening.

During Inca rule in ancient Peru, black dogs and black llamas were used in public ceremonies toward the end of the dry season. The animals were tied up, starved, and forced to cry from hunger and thirst, in the hope that the deities, in sympathy, would provide ample rainfall. In wartime, these two animals were weakened in the same way and then sacrificed. Inca priests prayed that their enemies would be equally weakened in body and spirit.

In central Mexico, the monkey was known as *ozomatli*, which was also the name of a day on the Maya calendar. People born on that day were generally considered to be lucky and happy persons. A monkey's hand was considered a talisman of good luck, in the same way that some people believe a rabbit's foot will bring good luck to them.

In certain parts of early Peru, people believed that a spider's movement could foretell the future of an event. The spider was kept in a jar. If any of its legs were bent when the spider was first viewed, it meant the event would turn out badly. Closeness to nature and a love for animals is still reflected today in much of Latin America's modern art.

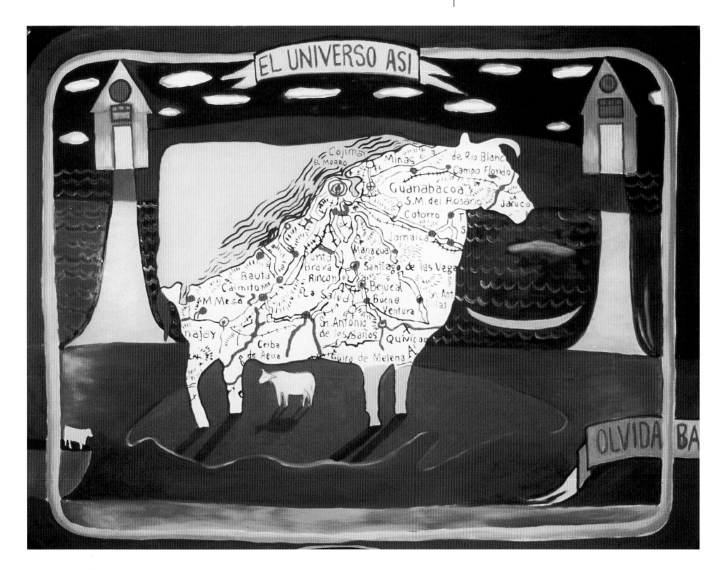

This Is the Universe (El Universo Así)
Nereida García-Ferraz is a modern Cuban artist who now lives in the United States. The animals in her paintings are usually symbols for people. In this work, the body of a large cow outlines a map of Cuba. One small calf is close to its mother, while another calf is separated by a body of water. Can you imagine that the small calf standing alone is a symbol for the artist herself? Separated from her old life, perhaps the artist is saying that she is homesick for her family and her country.

Nereida García-Ferraz (Cuba; b. 1954), 1997. Oil on stonehenge paper, 39" x 50" (99 x 127 cm). Photo courtesy of the artist.

Early art tells us how people looked, dressed, and lived. It reveals the importance of religion in every aspect of their lives.

MOST ORDINARY MEN in ancient times were farmers who grew corn, peanuts, chili, beans, and other fruits and vegetables. If they lived along a large body of water, they were fishermen. When the growing and fishing seasons were over, the men labored to build temples and roads. In wartime, they became soldiers. Religious rites accompanied every occupation.

Women tended fields by day and worked at spinning and weaving at night. They prepared family meals and clothing, and cared for the children, who began helping their parents as soon as they could

Veracruz, Girls on a Swing
Twin whistles show the Veracruz style of dress. The girls' skirts are shaped by the clay, but details of their clothing and facial decoration are painted. The hairstyles are different, but both wear earspools. The pose of these girls is typical of the realistic art forms produced by the Veracruz people.

Mexico, 300–600 AD. Painted clay whistles (with modern rope), 6" x 6" (15.2 x 15.2 cm). Courtesy National Museum of the American Indian, Smithsonian Institution.

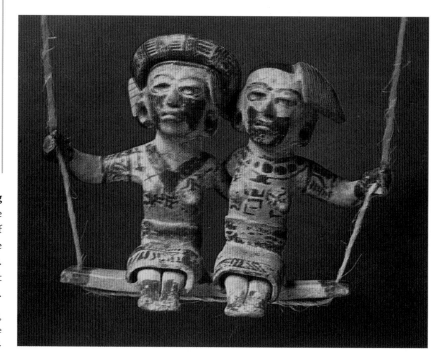

Colima, Vessel with Zapotes (Plums)

A well-shaped pot tells us that Colima farmers provided nutritious plums for the diet of their people, and that Colima artists handled clay with skill.

West Coast Mexico, 100 BC to 250 AD. Ceramic, 6 $^{1}/_{2}$" x 11" (16.5 x 28 cm). Courtesy Douglas Dawson Gallery, Chicago, Illinois. Photo: Dorothy Chaplik.

walk. There were times for play, as well. Mothers trained their daughters and fathers supervised their sons.

In Peru, there were special ceremonies for girls and boys when they reached puberty. For girls, there were family feasts and gifts, and a new name given by an uncle. Boys in the community celebrated together publicly. They were given new names and colorful breechcloths, the basic garment for a man. The ritual was simple for ordinary boys, but for sons of noble birth, the festivities would sometimes last several weeks.

At age fifteen or sixteen, Aztec boys could choose a school that taught citizenship, the bearing of arms, arts and crafts, history, and religious observance. Or, they could attend a school that taught priestly duties and rituals. Young women, too, could become priestesses at schools where they also learned weaving and featherworking for priestly garments.

A religious ball game was practiced in Middle America, and at times played for fun as a spectator sport. It was performed in a large court. High walls on opposite ends held a stone or wooden ring, much like basketball—except the ring was set vertically, not horizontally. Points were scored when a player struck a hard rubber ball through the ring. In most versions, players could strike the ball only with elbows, shoulders, hips, or legs. Religious games often ended with the sacrifice of humans to the gods. In some cultures, the victors were sacrificed; in others the losers were. To many people, the

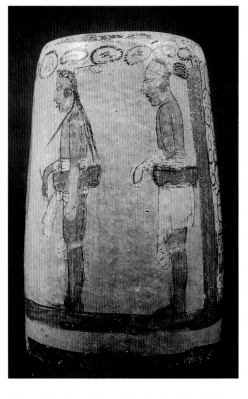

Maya, Cylindrical Vessel Depicting Four Ball Game Players

Two ball game players are shown on one side of a Maya ceremonial vase. Around the players' hips are yokes, perhaps made of leather. These were used to direct a rubber ball through a high hoop. Since hands were not used to hit the ball, players would fall to the ground to better aim the yoke.

Mexico, 600–900 AD. Painted ceramic, 7 $^{1}/_{4}$" x 4 $^{3}/_{4}$" (18.4 x 12 cm). New Orleans Museum of Art: Museum purchase through the Ella West Freeman Foundation Matching Fund. Photo: Davis Art Slides.

Ball Game Player (Jugador de Pelota)

Ancient ball players sometimes wore heavy gear during their games. A modern Mexican artist found inspiration for this print on the carved walls among the Maya ruins he often visits in Chichén Itzá.

Eliezer Canul (Mexico; b. 1927), 1968–69. Woodblock print, 6 $\frac{1}{2}$" x 3 $\frac{1}{4}$" (16.5 x 8.3 cm). Collection of the author.

Tlatilco, Life/Death Mask

A Tlatilco mask is half face and half skull. The dualities of life and death, light and shadow, and day and night were part of the world of opposites honored by early peoples, in both ancient Mexico and Peru. There is evidence that the Tlatilco people existed as early as 1200 BC.

Mexico, c. 800 BC. Pottery. Drawing by Erin Culton, after Bushnell.

game represented life, death, and rebirth. Others saw the movement of the ball as a symbol of the sun's journey through the sky.

Birth and death were honored by most ancient peoples as part of the duality of their universe. They believed that life continued after death, just as nature renewed the growth of leaves, flowers, and grasses from season to season.

COLONIAL LIFE

BECAUSE CHRISTIANS AND INDIANS both felt deeply about their religions, it was inevitable that their rituals became blended. New objects and materials arriving from Spain brought changes to the religious customs and art forms of the people. Conduct of everyday life changed as well.

Indian artists copied from European models when they created Christian art. But in their hands, the art was altered to reflect their world. Often they added foliage and birds from their own regions to sacred paintings, or dressed holy figures in native garments. Later artists gave a human quality to sacred figures by painting them in domestic settings. In doing so, they revealed the interiors of certain colonial homes. Portraits of the period, both religious and nonreligious, show the influence of European fashions on colonial dress.

During the colonial period, which lasted about 300 years, many marriages took place between Indians and Europeans. The growth of the large mestizo population contributed to new directions in art.

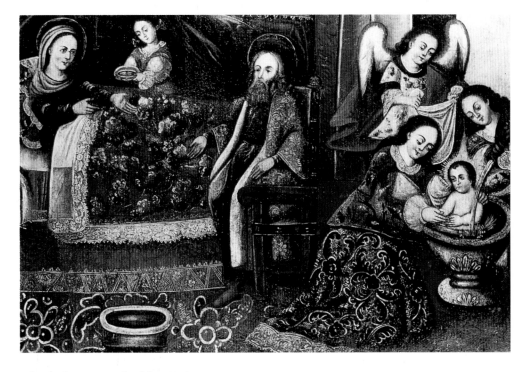

School of Cuzco, Birth of the Virgin
The mother of the Virgin Mary is painted as if she has just given birth to an ordinary infant. All the people in the room seem natural, rather than sacred. The well-furnished room reflects a comfortable colonial home in Peru, and is decorated with the fine laces and fabrics made in that region.

Peru, 16th–17th century. Oil, 27" x 20 $^{7}/_{16}$" (68.5 x 52 cm). New Orleans Museum of Art: Museum Purchase through the Ella West Freeman Foundation Matching Fund. Photo: Davis Art Slides.

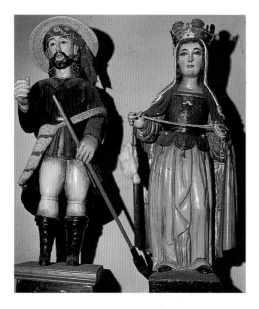

Colonial Figures

Two holy figures made of wood show the Spanish influence on clothing worn by Guatemalans in colonial times. The male figure represents St. Isidore, the farmer, and the female figure symbolizes the Virgin Mary. Some items they wear or hold are actual objects, not carved replicas. Can you identify them?

Church of Todos Santos, Guatemala, 18th century. Painted wood. Photo: Davis Art Slides.

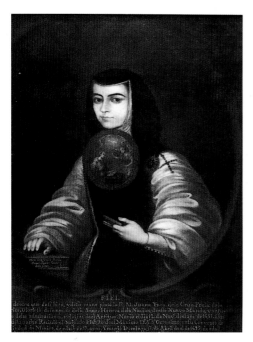

Lady with Miniature

Not all colonial art was religious. This portrait shows the European manner in which wealthy ladies of the times dressed.

Celestino Figueroa (Columbia, d.o.b. unknown), 1840. Oil on canvas, 27" x 20 ½" (69 x 52 cm). New Orleans Museum of Art: Gift of Mr. and Mrs. Harold Forgotston. Photo: Davis Art Slides.

Portrait of Sister Juana Ines of the Cross (Sor Juana Ines de la Cruz)

Sister Juana was a gifted poet and writer, who entered a convent at the age of sixteen. Her handsome religious habit suggests the imported elegance of high Spanish fashion.

Mexico. Artist unknown, 18th century. Oil on canvas, 41" x 34" (104 x 86.4 cm). Philadelphia Museum of Art: The Robert H. Lamborn Collection. Photo: Graydon Wood.

A Spanish art form known as votive art was favored in colonial Mexico, and remains popular today. Votive art expresses a person's gratitude for a miracle performed by a saint: perhaps an extraordinary recovery from serious illness, accident, or threat of death. Votive art takes the form of small, narrative paintings, often painted on tin. The painted picture stories are also known as *milagros* (miracles) or *retablos*. The name *retablo* developed because the paintings usually hung in the church, close to the wall known as the *retablo,* located behind the altar or shrine.

In Mexico, the earliest *retablos* were framed oil paintings on canvas or wood, affordable only by the wealthy. Later, when tin was imported from Spain, artists discovered that oil paint could be

Retablo

The *retablo* tradition that began in colonial times continues today. A twentieth-century Mexican offers thanks to the Virgin of San Juan of the Lakes for saving his mules when they were afflicted with encephalitis.

Mexico, 1971. Oil on tin, 8" x 7" (20.3 x 17.8 cm). Collection of William S. Goldman, Chicago, Illinois. Photo: Erin Culton.

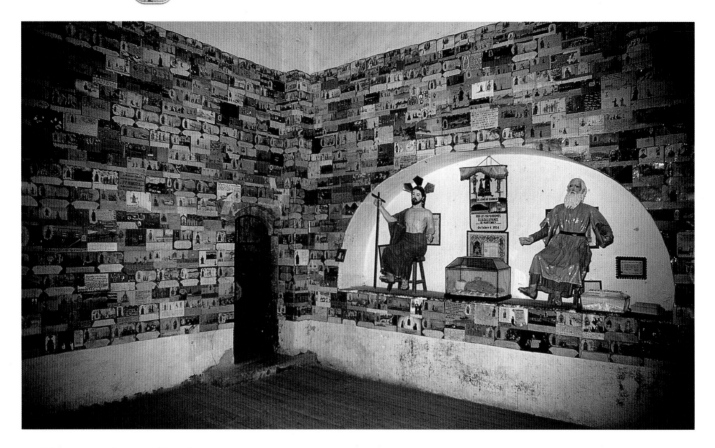

Retablos, Lining Church Walls and Altar

The walls of a Mexican church are hung with *retablos*. Each expresses gratitude, in pictures and words, for a miracle performed by the saints.

Rio de Catorce, San Luis Potosí, Mexico. Photo: Davis Art Slides.

applied to tin inexpensively. This meant that ordinary people could afford to have *retablos* made. Today these paintings, not always on tin, hang in shrines and churches throughout Mexico.

In colonial Peru, *retablos* had a different form. They were small portable altars containing images of Spanish saints. Missionaries brought them to the colonies to help convert Indians to Catholicism. *Retablos* intended for the natives were made of clay, leather, and plaster, while those for Spanish dignitaries were fashioned from gold, silver, and alabaster. Traditional *retablos* opened to two levels. The upper level was devoted to the usual saints. The lower one was devoted to the patron saints of animals: bulls, goats, mules, etc. By the seventeenth century, *retablos* were used in rural communities for cattle-branding ceremonies. In this way, the people brought an awareness of the holy or spiritual aspect of life into ordinary daily events.

FOLK ART

THE TALENTS OF ANCIENT INDIAN CRAFTSPEOPLE passed from one generation to the next, and were shared with mestizo artisans. Indian skills in handling clay, plant fibers, feathers, shells, and metals helped them adapt to European materials and methods that were introduced during the colonial period. Folk art, also known as popular art, is often made by self-taught artists. It is found in the marketplace as well as in museums and galleries. Much of everyday life is revealed in folk art, sometimes by its use and sometimes by the idea it expresses.

The production of folk art by unschooled artists is a large industry in most countries today. Some objects are made for daily use, others for decoration. Folk art provides income for the makers. Members of an entire family—father, mother, and children—often participate in the creation of a single item.

Indian artists had always worked well with clay. With the arrival of Christianity, they added crucifixes and saints to their production. Ancient potters had fired their pieces in an open fire or in a pit in the ground. With the potter's wheel and the enclosed kiln introduced by the Spanish, artists could work faster and more evenly, with better temperature control. Today many communities use modern methods to make ceramic pieces, while others shape and fire clay in the old familiar ways.

> Art forms tend to change over the years, but even today, with new resources and new shapes, folk art can reflect ancient roots.

Mother and Children (Madre y hijos)
A simple clay figure from Paraguay reminds us that mother-and-children relationships are the same everywhere. The artist shaped the clay by hand and decorated it with red slip, working in the way of ancient potters.

Maria Mercedes Esquivel (Paraguay, d.o.b. unknown), 1990s. Ceramic, 10" x 5" (25.4 x 12.7 cm). Tabati, Paraguay. Collection of the author. Photo: Erin Culton.

The Gossipers (Las Chismosas)
A circle of six gossiping women is a popular folk art theme in Peru. Like many Peruvian women today, the figures wear patterned skirts or aprons, and hats that could be made of felt.

Ayacucho, Peru. Artist unknown, 1990s. Ceramic, circumference: 17" (43 cm); height: 5" (12.7 cm). Collection of the author. Photo: Erin Culton.

Woodcarving developed from the early missionaries' demand for religious figures, but eventually the desires of the people for sacred carvings kept the industry going. When the church ceased to supervise religious art, carvers became self-taught and worked at home, often producing *santos de palo* (saints of wood) for their own devotion.

While many carvers today specialize in religious items, others create images of ordinary people and animals, birds, oxcarts, masks, and frames. In Peru, a wooden *retablo* may have hinged doors that open to reveal fiesta figures and musicians instead of saints.

Paper is another popular material for making folk art. Before the Spanish introduced thin paper, Mexicans made a thick paper from maguey plant fibers. This paper was used only for sacred writings. (Messages were written in picture symbols on cotton cloth.) Today, a heavy Mexican paper made from the bark of the amate tree resembles the ancient paper, but is smoother in texture. Artists paint colorful scenes from everyday life on its surface, or cut silhouettes of the ancient deities and mount them on amate paper of a contrasting color. (See opening page of this book for an example.)

Artists also frequently use papier mâché (shredded paper mixed with glue or paste) to construct fanciful figures of animals, humans, devils, and mermaids. Both ancient cultures and Christian rituals emphasized the theme of life and death. Therefore, this

Whimsical Animal

The traditional love of animals is reflected in this graceful Mexican carving. Several people probably contributed to its making. One carver may have shaped the body while another formed the ears, antlers, tail, and mane, and fit them into small slits in the wooden body. The paint was likely applied by yet another person.

Ayutla, Oaxaca, Mexico. Signed "Tribus Mixes," 1990. Wood, paint, plant material, 8" x 8" x 2" (20.3 x 20.3 x 5 cm). Collection of the author. Photo: Erin Culton.

Saints (Santos)

Carvers of religious items often have no special training and sometimes use makeshift tools. Yet the carver's deep religious feelings usually are transferred to the *santos*. The heart guides the hand.

Chichicastenango, Guatemala. Artist unknown, 20th century. Painted wood, dimensions, left to right (height, width, and depth):
(A) 14" x 5 $^3/_8$" x 3 $^1/_2$" (35.6 x 13.5 x 9 cm).
(B) 16 $^3/_4$" x 7 $^3/_4$" x 2" (42.5 x 19.7 x 5 cm).
(C) 14 $^3/_4$" x 6 $^1/_4$" x 3 $^1/_2$" (37.5 x 16 x 9 cm).
(D) 14" x 3 $^3/_4$" x 3 $^1/_4$" (35.5 x 9.5 x 8.2 cm).
Collection of William S. Goldman, Chicago, IL. Photo: Erin Culton.

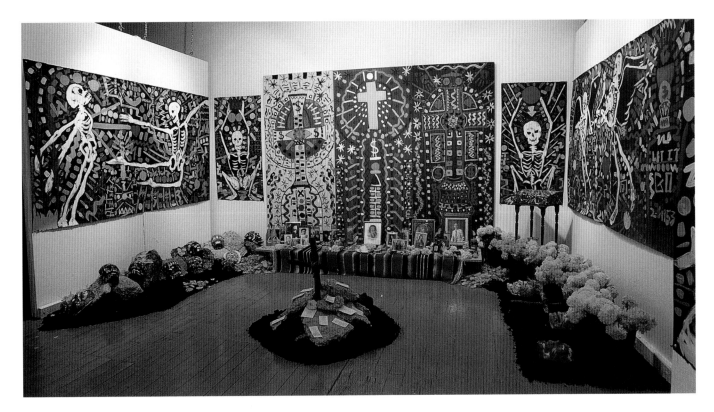

theme is often seen in popular art. This is particularly true in Mexico, during the celebration each year of the Day of the Dead, a holiday also celebrated by Mexicans in the United States. During this festival, Mexican stores sell toys, candies, and baked goods in the shape of skulls. Parties are held at cemeteries to await the return of the souls of the dead. It is also a time when artists—trained and untrained—are inspired to create new works of art with a theme of life and death.

Let It Go

Tony Galigo is a trained artist of Mexican heritage who lives in the United States. He painted an altarpiece in the corner of a room to celebrate the Day of the Dead. How do the traditional folk art themes give expression to his work?

Tony Galigo (Mexican-American; b. 1953), 1995. Altarpiece, acrylic paint and other objects. Collection of the artist. Photo courtesy of the artist.

Calaca (Skeleton) of the Doctor

How has this modern artist used humor with the theme of life and death? A skeleton figure holds a medical bag overflowing with dollar bills, among other things.

Miguel Linares, (Mexico, b. 1946), 1990. Papier mâché, 24 1/2" x 12" x 8 1/2" (62.2 x 30.5 x 21.6 cm). Mexico. Collection of William S. Goldman, Chicago, Illinois. Photo: Dorothy Chaplik.

Skull of the Fashionable Lady (La calavera catrina, also known as Calavera de la cucaracha)
Artist José Posada's skull figure made fun of stylish women. The way he combined skulls and skeletons with sarcasm or humor influenced later Mexican artists. An experienced printmaker, Posada created this caricature for a Mexican newspaper.

José Guadalupe Posada (Mexico; 1852–1913), 1913. Zinc etching. Tinker collection. Art collection, Harry Ransom Humanities Research Center. The University of Texas at Austin.

Fantasy Creatures
The unknown creator of this flat steel sculpture was inspired by Haiti's voodoo religion and ancient African legends. The supernatural figures, which are part animal and part human, are cut from a discarded oil drum.

Haiti. Artist unknown, 1970s. Steel, 12" x 15" (30.5 x 38 cm). Collection of the author. Photo: Erin Culton.

Folk artists today sometimes use skulls and skeleton figures to criticize or make fun of their society. This type of art reflects the influence of José Guadalupe Posada, who was one of Mexico's first modern printmakers. Posada borrowed the ancient life and death theme for the caricatures he printed in broadsides (one-page newspapers). These broadsides circulated in Mexico around 1900.

Like their ancient ancestors, modern artists use materials found in their environment to create endless forms of folk art. Baskets, hats, and bags are made with plant fibers. Jewelry is fashioned from seeds, shells, gourds, bones, and other natural materials. Dried and braided vanilla beans are shaped into hearts, flowers, and animals, some with glass beads for eyes. The Kuna women sew colorful *molas* from panels of cotton fabric (see the title page for an example). Haitian artists cut images of supernatural creatures from discarded oil drums. With nature's abundant supply of raw materials, and civilization's mass of discards, artists seem never at a loss to create new products.

Making a Cut-paper Mola

OVER A HUNDRED YEARS AGO, women of the Kuna culture (of the San Blas Islands off the coast of Panama) began decorating their blouses in a unique manner. Stitching together several layers of fabric, the Kuna women cut away sections of cloth to expose the colors beneath. Their stylized designs are often based on items in nature. The word *mola* means blouse in the Kuna language, but has come to mean the technique itself. Molas can be made from two to ten or more layers of fabric. In this activity, you will use layers of paper, instead of cloth, to imitate the mola technique.

Teacher sample, made with construction paper and a gluestick. Gluesticks are neater, but white glue tends to stick better. Use whatever works best for you.

Draw several natural objects, plants, or animals. Do sketches of different arrangements of these objects. Keep it simple. Select three colors of construction paper plus black, which is often the top color. Traditionally, the bottom color is also black, but you choose whatever you like.

1 Draw your design on the top color. Make it large, to allow for layers of colors that will appear inside the shape. Kuna artists unify their design with a repeated pattern of rectangles around their major shapes. You may choose to do the same. Carefully cut out the slots and design.

2 Choose the second color and lay it underneath the top cut-out layer. Clip or glue the two sheets together. With a pencil, draw the design again on the second color, about 1/8" to 1/4" inside the edge of the main design. Cut out this layer.

3 Put the third color underneath these two sheets and repeat the same process.

4 After cutting the third layer, put the bottom layer under the cut layers and glue everything together.

OPTION

When cutting inside your main design, you can cut other shapes rather than following the same outline. This will give your design variety and detail.

Turtle illustrations at left courtesy of Jo Miles Schuman, from her book *Art From Many Hands*.

ARTISTS OF TODAY

Modern artists express themselves in a variety of art styles. They offer new visions of everyday life, and show how people all over the world are similar. Their art may or may not reflect their heritage.

PRE-COLUMBIAN ART was closely tied to the religious values of ancient cultures, and art of the colonial period centered on Christian images. In contrast, modern art is not limited to religious expression. It is often a personal statement about an extended world as seen through the artist's eyes. The broader world of the artist is due, in part, to the ease of modern transportation and communication, which allows artists to travel widely or make their homes in other countries. In addition, televison, magazines, and computer technology have brought world events into the most remote of households.

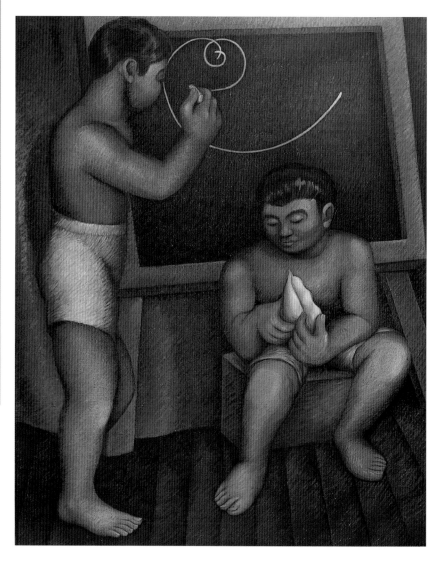

At School (En la escuela)
Could these Mexican schoolboys be daydreaming? What does the painting suggest to you? What meaning could the seashell have?

Agustín Lazo (Mexico; 1896–1971), 1943. Oil on canvas, about 4' x 3' 2" (122 x 96.5 cm). Collection of Museo de Arte Moderno and INBA, Mexico, D.F. Reproduction courtesy Museo de Arte Moderno. Photo: Paulina Lavista.

After the development of the camera, it became easy to record the appearance of objects. Artists then began searching for other approaches to art, and found new ideas in scientific discoveries. The telescope has shown what is happening millions of miles away, on earth or in space. The microscope has revealed activity beneath the surface of objects. The study of human behavior and new theories of psychology have suggested hidden depths of the mind. This has led modern artists to expose unseen aspects of their subjects, perhaps the weight or the inner structure of an object, or the thoughts, feelings, and imagination of a person.

For example, in Agustín Lazo's painting *At School,* look closely at the unusual attire of two students and the seashell they are studying. Although Lazo's forms and figures are clearly drawn, there is also something beyond reality in his painting. You can only guess the meaning. Each person may interpret the work differently, based on his or her own experiences.

Some artists rearrange nature, as Roberto Matta does in *Boxers,* where arms and fists fly, and you see them in several positions at once. Matta has captured the movement of the boxers, although the bodies are incomplete. In abstract art, it is not unusual to find certain elements exaggerated, or to find other forms totally or partially unrecognizable.

The sleek, three-dimensional motorcycle sculpture by Luis Jiménez is easily recognized. Yet, an air of mystery and tension seems to hover over cycle and rider.

Cycle (also known as Filo)
Inspiration for this sculpture grew from the artist's observation of motorcycle activity around the Texas-Mexico border at El Paso. What meaning could *filo* (a Spanish slang word for knife) have in this work?

Luis Jiménez (Mexican-American; b. 1940), 1969. Fiberglass and acrylic urethane, length: 7 1/2' to 8' (2.3 to 2.4 m). Reproduction courtesy of the artist.

Marisol's sculptural portrait of *Andy* combines unusual materials. She has included an actual pair of shoes and real chair legs, together with painted images, pencil drawings, and wood construction. Could the artist be making a comment about Andy, or about herself, or about the world in general?

The details of the painting by Cundo Bermudez are realistic, except for the twin images of the barber and his client. What meaning could there be in this imaginative twist of reality?

Andy

Marisol is an artist who has lived on several continents, including North America. Here she presents a playful portrait of fellow artist Andy Warhol. She has drawn and painted his seated body on wooden boards, supported at the back by two real chair legs. The model's worn shoes extend from the painted ones. What does this work tell you about Marisol?

Marisol (Venezuela; b. Paris, 1930), 1963. Pencil and paint on wood construction, plaster, with Warhol's paint-splattered leather shoes, 56 1/2" x 17 1/4" x 22 1/2" (143.5 x 43.8 x 57 cm). The Lindy and Edwin Bergman Collection, Chicago, Illinois. Photo: Seymour Chaplik.

The Barber Shop (La barbería)

This artist takes us into an old-fashioned barber shop in his native Cuba, which he painted before he left his country. The realism of the painting is offset by the mirror-image profiles of the two men, possibly a double self-portrait. What does the work tell you about the artist?

Cundo Bermúdez (Cuba; b. 1914), 1942. Oil, 25 1/8" x 21 1/8" (64 x 54 cm). Collection of The Museum of Modern Art, New York. Inter-American Fund. Photograph ©1999 Museum of Modern Art, New York.

In Juan Soriano's *The Bicycle Circuit at France,* vivid colors and an abstract style create a particular mood. How do the figures and colors affect your feelings?

Rafael Tufino's *Reading* (see page 1) also reflects bright color, but without abstraction. The figures and shrubbery are clear and realistic. What thoughts or feelings are evoked in you by this work?

A clue to understanding Lorenzo Homar's *Heroic Alphabet* (page 114), is in its title. Combining abstract color shapes and realistic letters, Homar calls on the viewer to think about the ways in which our alphabet gives meaning to our lives.

As you study the modern works in this section and in the next chapter, you will recognize the difference between abstract art and figurative art, where objects are clearly recognized. In some cases, the artist may combine the two styles. Whether the style is abstract or figurative, realistic or imaginative, the observer must learn to look and look and look again to understand the artist's thoughts and feelings.

The Bicycle Circuit at France (La vuelta a Francia)

A bicycle race is described in an abstract painting by Juan Soriano. Human and animal cyclists are almost skeletons. The repetition of wheels, dabs of bright color, and swift brushstrokes suggest the nervous excitement of a racing event.

Juan Soriano (Mexico; b. 1920), 1954. Oil on canvas, about 3' 2" x 4' 9" (96.5 x 145 cm). Collection of the Museo de Arte Moderno and INBA, Mexico, D.F. Reproduction courtesy of the artist and Museo de Arte Moderno. Photo: Paulina Lavista.

Modern Latin American artists work in a variety of international styles, modified by their own unique approach and their individual sense of beauty. Their work may or may not reveal their national origins.

THE WORKS OF MANY ARTISTS reflect their Latin American roots. They may refer openly to their pre-Columbian, African, Spanish, Portuguese, or other European ancestors, or they may use subtle, indirect ways to show their identity. Other artists make no reference to their origin and instead deal with universal interests or problems shared by people around the world. The same artist may work in both modes at different times.

Carlos Mérida, of Guatemala, reflects his native roots in an abstract geometric painting. In *City Landscape No. 1,* he has reduced a city to geometric shapes. Pyramid forms, *zócalos* (city squares or

City Landscape No. 1 (Paisaje de la urbe no. 1)
In this abstract painting, city streets, walls, and buildings become geometric shapes. Some suggest the church towers, steeples, and plazas of Latin America's colonial architecture, while the overall arrangement resembles the designs of old Indian weavings from Guatemala and Mexico.

Carlos Mérida (Guatemala; 1891–1984), 1956. Oil on canvas, about 30" x 40" (.75 m x 1.0 m). Collection of Galería de Arte Mexicano, Mexico, D.F. ©Carlos Mérida/SOMAAP, Mexico, 1999. Photo: Paulina Lavista.

Hibiscus, or Pacific Sea Flowers (Marpacifico)
Cuba's clear sunlight, its brilliant tropical plants, and the surrounding sea are in the light-filled colors of this abstract painting.

Amelia Peláez, (Cuba; 1897–1968), 1943. Oil, 45 $^{1}/_{2}$" x 35" (115.5 x 89 cm). Gift of IBM. Collection of Art Museum of the Americas, Organization of American States, Washington, D.C. Photo: Angel Hurtado.

plazas), and an arched doorway mark the Indian and Spanish influences on the landsape of Latin America. Like many modern painters, Mérida works in a flat style. The way some shapes overlap one another suggests a bit of space behind them.

The painting by Amelia Peláez titled *Hibiscus* describes in subtle ways the artist's home and garden in her native Cuba. Many old Spanish homes in Cuba have colorful stained-glass windows decorated with black iron gratings bent into designs. Peláez' style is also flat. Her designs are close to the front surface of the canvas. She did not show deep space behind them, as you might find in a traditional painting of a home and garden.

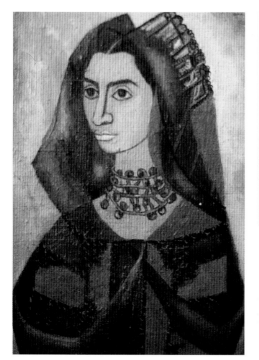

The Spanish roots of Cundo Bermúdez are reflected in the costume worn by his model in *Portrait of the Artist's Niece*. Cuba, too, is reflected in his niece's gown, through vivid colors and dark lines that suggest the country's stained-glass windows. Painting in different styles, both Bermúdez and Peláez have used elements of their homeland to compose their art. Bermúdez' style is figurative and realistic, while Peláez works in abstract terms.

Also realistic and figurative is the work of Fernando Botero. He was born in Colombia, but is at home on several continents. A painter and sculptor, he works in a classical, traditional style,

Portrait of the Artist's Niece
The *mantilla* (headscarf) and tiara worn by the artist's niece emphasize the Spanish heritage of the painter. What similarities do you find in this figurative painting and the abstract painting by Amelia Peláez on the previous page?

Cundo Bermúdez (Cuba, b. 1914), 1947. Oil on burlap on cardboard, 21" x 15" (53.3 x 38 cm). Private collection. Reproduction courtesy of the artist. Photo: Dorothy Chaplik.

Cat
An oversized cat looks out at the world with curious eyes. Its enormous size suggests the power of ancient felines. Does this cat look ferocious? What meaning do you see in the bell around its neck? The artist, a long-time student of pre-Columbian history, has created a series of large sculptures, both human and animal. After drawing many sketches, he makes plaster models of his subjects and sends them to a foundry to be cast in bronze.

Fernando Botero (Columbia, b. 1932), 1976-1977. Bronze, about 120' (36.6 m). Photo: Davis Art Slides.

although he makes his subjects larger than life. In what way could his sculpture of a large cat relate to his pre-Columbian ancestors?

The Mexican artist Frida Kahlo, in *Self-portrait with Monkey and Parrot,* painted herself in a regional Mexican costume. How does the background also assert her pride in her country? Frida Kahlo was the wife of another artist, Diego Rivera (see his artwork on pages 16, 66, and 68). He is famous for his murals, and she is known for her self-portraits, many showing her in traditional Mexican clothing.

Photographer Graciela Iturbide emphasizes her Mexican background in a different way. She travels to remote Indian villages in Mexico and records their ancient lifestyles—how people work and how they live. Though the camera's eye is realistic, in *Hand Play* she captures a mood of magic among children at play. The element of fantasy in this photograph touches on surrealism, an art movement that involves dreamlike images.

Self-portrait with Monkey and Parrot (Autorretrato con chango y loro)
Showing strong identity with her native country, artist Frida Kahlo paints a self-portrait in front of tropical foliage. She is wearing the dress and ribboned hairstyle of Mexico's Tehuantepec region. Like her pre-Columbian ancestors, she has made pets of the monkey and parrot.

Frida Kahlo (Mexico; l907–54), 1942. Oil on masonite, 21 1/2" x 17" (54.6 x 43 cm). Collection of Fundación Eduardo Costantini, Buenos Aires, Argentina. Courtesy Sotheby's, New York. Photo: Geoffrey Clements.

Hand Play (Juego de Manos)
This photographer recorded a scene in a Mexican village where people still follow ancient ways of life. The play activity here reminds us that children of all times and places entertain themselves in similar ways. On the wings of their imagination, they invent games to amuse or frighten each other.

Graciela Iturbide (Mexico; b. 1942), 1988. Gelatin silver print. Juchitán, Oaxaca, Mexico. Photo courtesy of the artist.

UNIVERSAL INTERESTS

> The ethnic background of an artist is not always evident in his or her art. Often more universal themes are being expressed, such as the concept of time, the importance of families, or environmental issues.

MODERN ART is often rooted in recent technology or in international interests. More inventions and scientific knowledge have been developed in the last century than in all previous eras of human development. Instant communication through telephone, television, and the Internet has brought new technologies and new world problems into everyone's home. These things often provide new ways of thinking for modern artists.

Angel Hurtado, a native Venezuelan who lived for a long period in the United States, finds inspiration in the exploration of outer space. His planetary landscape *Triptych (Mars-Venus-Mercury)* consists of three separate scenes. They feature orbs floating in space and invite observers to share the artist's dream of other worlds—life on Mars? Interplanetary wondering? Or, perhaps, a private dream from the magic spaces within your own mind.

Mexican-born Alfredo Arreguín has resided in the United States since his college days. His painting *At Night the Salmon Move*

Triptych (Mars-Venus-Mercury) Inspired by recent discoveries on the moon, this artist created his own poetic vision of planets floating in space. To create lines and textures in this triple landscape, he shaped layers of transparent paper, both colored and white, and coated them with acrylic paint and varnish.

Angel Hurtado (Venezuela; b. 1927), 1971. Collage, 39 1/2" x 60" (100 x 152.4 cm). Collection of Ambassador and Mrs. Gonzalo García-Bustillos, Washington, DC. Photo: Angel Hurtado.

comes from his concern for the survival of the fish in tainted waters. Pollution is an environmental problem facing people today in many places. Although Arreguín's subject is universal and modern, his painting style has a baroque quality that echoes the intense decoration of Latin American churches. The same dense quality appears in the thick and abundant foliage that surrounded Arreguín as he grew up in Mexico.

Interior of Santa Maria Tonantzintla Church
The decoration in this colonial church is typical of the baroque style brought to Latin America from Europe. Notice all the carved designs crowding the walls and ceiling. Do they remind you of the crowded patterns in the painting of salmon?

Puebla, Mexico, 18th century. Photo: Davis Art Slides.

At Night the Salmon Move
An underwater scene of salmon on the move stems from the artist's concern that salmon are becoming an endangered species. He crowds the canvas with shape, color, and movement. His style may come from his early exposure to the dense rain jungles of Mexico, as well as his familiarity with the heavy decoration of Mexico's baroque churches.

Alfredo Arreguín (Mexico; b. 1935), 1996. Oil on canvas, 72" x 48" (183 x 122 cm). Photo courtesy of the artist.

Pendulum (Pendulo)

This artist chose to carve his sculpture in a primitive style. His work suggests an ancient time and place, perhaps a home carved into the side of a mountain. Like his ancestors, the artist shows a concern with time, expressed by the pendulums suspended from bits of string and leather.

Gonzalo Fonseca (Uruguay; 1922–98), 1974–76. Sandstone, 18" x 16" x 12" (46 x 40.6 x 30.5 cm). Photo: Cheryl Rossum. Courtesy Caio Fonseca, New York.

The duality of universal and national themes in a single work occurs frequently. It is illustrated in the sculpture of Uruguayan-born Gonzalo Fonseca, who lived on several continents. *Pendulum* (an object associated with clocks) emphasizes the universal concern with time. His roughly carved stone house also refers to ancient societies the world over, including the pre-Columbian cultures of his native land.

Another universal theme appears in *Mother and Child,* by Wifredo Lam. This drawing also reflects aspects of Lam's native roots. Born and raised in Cuba, Lam was familiar with the African voodoo cults followed by some Cubans. Voodoo cults involve fetish figures and masks and gods that are part animal and part human, all of which are mirrored in this strange, yet maternal portrait.

Many Latin American artists express themselves through fantasy. Mexican-born Pedro Friedeberg takes a humorous approach in *Ornithodelphia,* a bird drawing that combines fantasy with Op art (an art movement based on optical illusions and geometric shapes).

Fantasy also dominates the colorful paintings of Eduardo Giusiano of Argentina. *Cinderella,* painted in a style known as figurative expressionism, depicts human figures in a fantastic vehicle. Like Giusiano, artists frequently distort the shape of their figures to give stronger emotion to their work.

Born in Argentina, Pérez Celis has worked in both New York City and Buenos Aires. His *Enduring Earth* (see page 112) is painted

Ornithodelphia: City of Bird Lovers

Using fantasy and humor, this artist frames the architecture of a city within the bodies of birds. The Op Art ground and geometric lines of the outer frame are in contrast to the realistic bird and building shapes. The title has its roots in the Greek word for birds.

Pedro Friedeberg (Mexico; b. 1937), 1963. Ink on paper. Collection of Mr. and Mrs. Norman Tolkan.

in a style known as abstract expressionism. Abstract work often has no recognizable forms, and therefore cannot be understood easily. Expressionist paintings, whether abstract or figurative, rely heavily on textures and color to add strong feeling to them. Just as the ancient people painted their art and architecture with bold color, and colonial churches were decorated with gold and richly colored paintings, modern artists use intense color to give their work more emotional force.

Mother and Child

Strange figures seem half animal or bird, with masklike faces, yet the mother is convincingly natural in the way she sits on a chair and holds her child. Can you find in this unusual but tender pose a suggestion of African voodoo cults?

Wifredo Lam (Cuba; 1902–82), 1957. Pastel drawing, 28 3/4" x 22 3/4" (73 x 58 cm). The Lindy and Edwin Bergman Collection, Chicago, Illinois. Photo: Seymour Chaplik.

Cinderella (La Cenicienta)

Like Cinderella fleeing from the ball at midnight, the occupants of this fantastic vehicle seem to be experiencing a stolen moment of joy. Giusiano's vibrant colors and swift brushstrokes create a sense of speed and excitement. Arms that end in feathered wings add to the movement.

Eduardo Giusiano (Argentina, b. 1931), 1987. Oil on canvas, 63" x 55" (160 x 140 cm). Reproduction courtesy of the artist. Photo: Pedro Roth.

Enduring Earth (Tierra Paciente)
Colors and textures give meaning to this abstract painting. Sometimes the title of a work is a clue to the artist's intention, but the viewer must often rely on the way the painting affects his or her feelings and imagination to find the meaning.

Pérez Celis (Argentina; b. 1939), 1989. Oil on canvas, 52" x 42" (132 x 107 cm). Photo courtesy of the artist.

Intense color is not a necessary element in all works of art. Color is often subtle in the collages of Cuban-born José Bernal, now a resident of the United States. Bernal collects materials with an eye toward creating three-dimensional collages, called assemblages. His *Unicorn* is composed of dissimilar, cast-off items. He has unified these found objects in a pleasing artistic arrangement that has meaning on a universal level.

The works of art shown in this book, from earliest pre-Columbian days to contemporary times, reveal characteristics they all have in common. Artists begin with materials from the earth—paint, stone, wood, clay—and transform them into a work of art. In assemblages made with found objects, the original material is given new life.

In each work, artists present their particular vision of life and reality. For the earliest cultures, that vision was based on their system of beliefs and gods. Religious faith inspired colonial art, which also recorded the secular (nonreligious) changes taking place in the New World. Contemporary artists may be influenced by science and technology and the course of modern events. At the same time, their particular themes may grow out of personal experiences. In most cases, the work of art records a bit of history, transformed by the artist's own sense of style and beauty.

Unicorn
The unicorn of this assemblage (three-dimensional collage) was created by adding a "horn" to a chess piece. Bernal's imagination and wit transform ordinary household objects into a unified work of art.

José Bernal (Cuba; b. 1925), 1981. Chess pieces, window frame, typewriter keys, and other found objects, 13" x 28" x 4" (33 x 71 x 10 cm). Reproduction courtesy of the artist. Photo: Michael Tropea.

Constructing a Collage or Assemblage

ARTISTS OF TODAY have a wide range of choices when it comes to materials. A collage or assemblage can say much about the lifestyle and environment of the artist. In this activity, you will select images or objects from daily life that express something that's important to you. Choose to follow suggestions in either 1 or 2 below.

Religious Community

Historically, Latin American art has been strongly influenced by the religious convictions of the people who live there. This student artist made her religious experiences a central focus in her collage.

Alena Sinacola, 2000. Collage, 10" x 15" (25.5 x 38 cm). Notre Dame Academy, Worcester, Massachusetts.

1 Collage

A collage, like the one on this page, is a two-dimensional artwork made by cutting, shaping, and pasting images onto a flat surface such as paper or cardboard.

- You can select old labels, tickets, postcards, photographs, magazine illustrations, newsprint, wrapping paper, leaves, flower petals, etc. Experiment with your composition by shifting your materials around the flat surface before pasting them down.

- The collage on page 108 uses layers of transparent paper, coated with acrylic paint and varnish. You can experiment with adding paint to an arrangement of cut and pasted materials.

- Not all collage materials have to be flat. You can add three-dimensional objects of varying volume. Sand, pebbles, twigs, and other textured materials can be added to your collage.

- Keep in mind that the mood of a collage can be expressed through choices of color and texture, the use of torn edges or cleanly cut images, and wrinkled or smooth surfaces.

2 Assemblage

Three-dimensional collages are known as assemblages, like the one on page 112 (opposite). The finished work occupies space like a piece of free-standing sculpture.

- Assemblages often include cast-off items, and sometimes are known as junk sculpture.

- A heavier support, such as plywood or masonite, is needed for bulkier pieces.

- When using a variety of materials, unify your work by repeating certain elements within the collage, such as colors, shapes, and textures.

RESOURCES

Heroic Alphabet (Alfabeto Heroico)
This alphabet is printed on an abstract background of color shapes. Why does the artist call our everyday letters heroic? What makes this a Spanish alphabet?

Lorenzo Homar Gelabert (Puerto Rico; b. 1913), date unknown. Screen print, 18 ⁷/₈" x 24 ³/₄" (48 x 63 cm). Reproduction courtesy of the artist.

GLOSSARY OF TERMS

abstract art Art that sometimes reduces the image to a few simple lines, colors, or textures, and sometimes has no recognizable shapes.

adobe Sun-dried mud, or a building made of this material.

alloy A mixture of two or more metals.

altar A table-like structure, often of stone, used for religious rites.

anthropomorphic Giving human characteristics and behavior to animals or inanimate objects.

assemblage A three-dimensional collage, in which the parts are assembled in a composition, rather than painted, drawn, or modeled.

baroque art A style of European art brought to Latin America after the Spanish conquest. Baroque architecture, sculpture, and painting combined elaborate decorations with dramatic movement and color.

ceramics Objects made of fired clay or porcelain.

codex (plural: **codices**) A manuscript book of laws, illustrated in ancient Mexico with glyph writing and picture symbols.

collage A composition made by pasting together various materials that are flat or have slight volume.

deity A god or goddess.

dome A rounded roof, often found in church architecture.

drypoint A printmaking technique of engraving on metal without the use of acid.

engraving The art of cutting lines into wood, metal, etc. A variety of techniques are used.

equinox The two times of the year when day and night are the same length.

etching A printmaking technique of engraving on metal, with the use of acid.

figurative art A work that involves the human figure, other creatures, or things.

folk art The products (painting, sculpture, ceramics, needlework, etc.) created by untrained artists. Objects may be functional or decorative.

found object Something found, rather than looked for, that has importance to an artist in a work of art.

fresco The technique of painting on wet lime plaster with waterbased pigments (known as true fresco).

fresco secco (dry fresco) The technique of painting on dry plaster.

114

frieze A plain or decorated horizontal band on the interior or exterior upper wall of a building.

geometric designs Designs based on geometric shapes, such as squares, rectangles, and circles.

geometric line drawings Drawings made with lines related to geometric shapes.

gesso A thin mixture of plaster of Paris, glue, and water. A base for painting and sculpture.

glyph A symbol for words or sounds used in hieroglyphic writing.

gouache A nontransparent watercolor.

hieroglyphic A system of writing that uses pictures or symbols to represent words and sounds.

homogeneous Related by common ancestry or culture.

indigenous Native to a region.

junk sculpture A type of freestanding assemblage made from cast-off materials.

lithograph A print that begins with a drawing made on a stone or a zinc plate with a greasy crayon.

lost wax process (cire perdue) A casting technique that uses a wax model coated with clay. When the hardened clay mold is heated, the wax melts (is "lost"), leaving a cavity into which liquid metal is poured. When hardened, the metal takes on the shape of the original wax model.

medium (plural: **media**) The material with which a work of art is created: oils, watercolor, wood, clay, stone, etc.

mosaic A decorative design on walls, floors, and so on made by embedding small stones or pieces of glass or ceramic in cement.

movement In motionless art, the various elements (line, color, shape, etc.) of a work that lead the observer's eye through the work.

obsidian A shiny volcanic glass with sharp edges.

Op Art An art movement based on optical illusions.

pastel A chalk stick made of colored powder and gum.

pigment A color substance extracted from animal, mineral, or vegetable, and mixed with oil or water to form a coloring medium.

plaster A white powder made from lime sand that forms a paste when mixed with water and hardens into a solid form.

plateresque A style of church decoration made from finely carved plaster.

poster A large printed announcement exhibited in a public place.

pottery Objects made from moist clay and hardened by heat.

print An impression taken (printed) from a block or plate made by using a variety of techniques. Usually printed on paper.

relief Carving or molding in which the design projects from the background.

repoussé Ornamental metalwork, in which a design is hammered into relief from the reverse side.

slip A thin, colored clay used to decorate clay figures and vessels.

solstice The longest day of the year (the summer solstice) and the shortest day of the year (the winter solstice) are produced by the position of the sun in the sky. In the Northern Hemisphere, the longest day of the year occurs around June 22, and the shortest day around December 22. In the Southern Hemisphere, the dates of the two solstices are reversed.

stonehenge paper The brand name of a 100 percent cotton paper used for drawing and printmaking.

stucco A building material made of a plaster-lime compound.

tempera A painting medium in which pigment ground in water is mixed with a gluey substance, such as egg yolk.

terra cotta A hard, fired clay, often a brownish red in color.

triptych A painted or carved work in three parts or panels.

votive art A painted or sculptured image dedicated to a deity or saint in gratitude for a miracle performed.

watercolor A transparent medium made with pigment ground with a binder easily dissolved in water.

woodcut Print made by engraving on a wood block.

zoomorphic Attributing animal characteristics to nonanimal beings or things.

When the Spanish recorded Indian words, they gave most vowels and consonants the Spanish pronunciation. Quechua was the chief language spoken in ancient Peru, and Náhuatl was the language of Middle America. However, because numerous other languages were also spoken, there are many differences in pronunciations. The following rules will be helpful, although there will be exceptions.

In general, words that end in a vowel, or in *s* or *n,* are accented on the next-to-the-last syllable, as in *Guatemala (Gwah-teh-MAH-lah).* All other words are accented on the last syllable, unless otherwise indicated by an accent mark.

C is hard, as in *cat,* except when followed by *h,* when it sounds like the English *ch,* as in *church.*

U, when it comes before *a, e, i,* and *o,* is often pronounced like the English *w,* as in *Cuernavaca (Kwer-nah-VAH-cah),* but when *u* comes after *q,* the two letters sound like *k,* as in *Quipu (KEE-pooh).*

Aleijadinho *(Ah-lay-jah-DEE-nyoh)* (Portuguese) Popular name of Antonio Francisco Lisbõa, Brazilian architect and sculptor.

Atahauallpa *(Ah-tah-ah-WHAL-pah)* Inca ruler.

Aztec *(As-TEHK)* Dominating culture in Valley of Mexico at time of conquest.

Bogotá *(Boh-goh-TAH)* Capital city of Colombia.

Bom Jesus *(Bohn JEH-soos)* (Portuguese) Church in Brazil. *See* Congonhas do Campo, Minas Gerais.

Bonampak *(Bohn-ahm-PAK)* Ancient Maya city, Chiapas, Mexico.

El Castillo *(EL Kah-STEE-yoh)* Maya-Toltec pyramid at Chichén Itzá, Yucatán, Mexico.

Centzonhuitznahuac *(Cent-zon-wheatz-NAH-wac)* Son or sons of Aztec earth goddess, representing the stars.

Cerro Gordo *(SEH-roh GOHR-doh)* Mexican mountain at Teotihuacán.

Cerro Tololo *(SEH-roh Toh-LOH-loh)* City in Chile, site of modern observatory.

Chac *(Chahk)* Maya rain god.

Chalchiúhtlicue *(Chal-chee-UUH-tlee-kway)* Aztec water goddess.

Chavín *(Chah-VEEN)* Early culture, ancient Peru.

Chiapas *(Chee-AH-pas)* Mexican state.

Chichén Itzá *(Chee-CHEN Eet-SAH)* Site of Maya-Toltec center, Yucatán, Mexico.

Chimú *(Chee-MOO)* Early culture, ancient Peru.

Coatlicue *(Koh-aht-LEE-kway)* Aztec earth goddess.

Congonhas do Campo *(Kohn-GOH-nyas doh CAHM-poh)* (Portuguese) Brazilian city in the state of Minas Gerais.

Copán *(Koh-PAHN)* Maya site, Honduras.

Cortez or Cortes, Hernán *(Cohr-TES)* Spanish conqueror of the Aztecs.

Coyolxauhqui *(Koh-yohl-SHAH-kee)* Aztec moon goddess.

Cuauhtémoc *(Kwah-ooh-TEH-mohk)* The last of the Aztec rulers.

Cuernavaca *(Kwer-nah-VAH-cah)* City in Morelos, Mexico.

Diquís *(Dee-KEES)* Region in Costa Rica.

Guadalupe *(Gwah-dah-LOO-peh)* City in Chihuahua, Mexico.

Huanacaúri *(Wan-ah-ka-OO-ree)* Sacred site in ancient Peru.

Huasteca *(Wahs-TEH-kah)* Region in northeastern Mexico.

Huitzilopochtli *(Wheat-zeel-oh-POHTCH-tlee)* Aztec god of sun and god of war.

Inca *(INK-ah)* Early culture, ancient Peru.

Kan Xul *(Kahn Shool)* A holy lord of Palenque.

Kinich Ahau *(Keen-EECH Ah-HAU)* Maya sun god.

Kukulcán *(Koo-kool-KAHN)* Maya creator god.

La Venta *(Lah VEN-tah)* Ancient Olmec site, Tabasco region, Mexico.

Lisbõa, Antonio Francisco *(Lis-BO-ah, Ahn-TOHN-yoh Frahn-SIS-coh)* (Portuguese) Brazilian architect and sculptor.

Machu Picchu *(MAH-choo PEE-choo)* "Lost" Inca city, ancient Peru.

Maya *(MAH-yah)* Early culture, Middle America.

Mexica *(Mex-EE-cah)* *See* Aztec.

Minas Gerais *(MEEN-ahs JEHR-eyes)* (Portuguese) Brazilian state.

Mixtec *(MEESH-tehk)* Ancient culture, Oaxaca region, Mexico.

Moche *(Moh-CHEH)* or Mochica *(Moh-CHEE-kah)* Ancient Peruvian culture.

Nahuatl *(NAH-wahtl)* Language of the Maya.

Nazca *(NAS-kah)* Ancient Peruvian culture.

Necrópolis *(Neh-KROH-poh-lees)* Ancient cemetery.

Nicoya *(Nee-KOY-ah)* Ancient culture, Costa Rica region.

Oaxaca *(Wah-HAH-kah)* Site of Mixtec and Zapotec cultures, Mexico.

Olmec *(OHL-mehk)* "Mother culture," Middle America.

Palenque *(Pah-LEN-keh)* Maya site, Chiapas, Mexico.

Paracas *(Pah-RAH-cahs)* Ancient Peruvian culture.

Pizarro, Francisco *(Pee-SAHR-roh, Frahn-SEES-coh)* Spanish conqueror of the Incas.

Ponce Stela *(POHN-seh STEH-lah)* Monument named for modern Bolivian archaeologist Carlos Ponce Sanginés *(Sahn-geen-EHS)*.

Popol Vuh *(POH-pohl Vooh)* Sacred text of the Maya Quiché Indians of Guatemala.

Pulque *(POOL-keh)* Fermented drink made from sap of the agave plant.

Pulquería *(Pool-keh-REE-ah)* Small bar where fermented beverages are sold.

Quechua *(KECH-uh-wah)* Language of the ancient Peruvians.

Quetzal *(KET-sahl)* Central American bird.

Quetzalcóatl *(Ket-zal-COH-atl)* Creator god of the Aztecs.

Quipu *(KEE-pooh)* An early Peruvian memory device to recall dates and events.

Sacsahuamán *(Sahk-sah-wha-MAHN)* Ancient building in Cuzco, Peru.

Santos de palo *(SAHN-tohs day PAH-loh)* Saints of wood.

Sicán *(See-KAHN)* Early culture, Peru.

Stela *(STEH-lah),* plural: Stelae *(STEH-lee)* Stone monuments marking important dates and events.

Taíno *(Tah-EE-noh)* Early culture, Caribbean region.

Tenochtitlán *(Tay-noch-teet-LAHN)* Sacred Aztec city, Mexico.

Teotihuacán (Tay-oh-tee-wah-KAHN) Ancient pre-Aztec city, Mexico.

Tikal *(TEE-kahl)* Sacred site, ancient Guatemala.

Tiwanaku *(Tee-whan-AH-koo)* Ancient empire, Bolivia.

Tláloc *(TLAH-lohk)* Teotihuacán god of rain.

Tlaloques *(Tla-LOH-kehs)* Assistants to Tláloc.

Tlatilco *(Tlah-TEEL-coh)* Early culture, Valley of Mexico.

Tlamanalco *(Tlah-mahn-AHL-coh)* Site of colonial architecture, Mexico.

Toltec *(TOHL-tek)* Early culture, Hidalgo, Mexico.

Totora *(Toh-TOH-rah)* Reeds used to build Moche fishing vessels.

Uaxactún *(Wah-shahk-TOON)* Maya ceremonial site, Guatemala.

Uxmal *(USH-mahl)* Maya ceremonial site, Yucatán, Mexico.

Veracruz *(Vehr-ah-KROOS)* Site of several cultures along Gulf of Mexico.

Viracocha *(Veer-ah-KOH-chah)* Creator god of the Incas.

Yucatán *(Yoo-kah-TAHN)* Mexican state, site of Maya ceremonial centers.

Zapotec *(ZAHP-oh-tehk)* Ancient culture, Oaxaca region, Mexico.

Zócalo *(ZOH-cah-loh)* Main square in city plaza.

BIBLIOGRAPHY

PRE-COLUMBIAN PERIOD

Arciniegas, Germán. *Latin America: A Cultural History.* New York: Alfred A. Knopf, 1970.

Bercht, Fatima, et al, eds. *Taíno: Pre-Columbian Art and Culture from the Caribbean.* New York: Monacelli Press and El Museo del Barrio, 1997.

Bernal, Ignacio. *The Mexican National Museum of Anthropology.* Mexico: Ediciones Lara, 1970.

Bushnell, G. H. S. *Ancient Arts of the Americas.* New York: Frederick A. Praeger, 1965.

Castedo, Leopoldo. *History of Latin American Art and Architecture: From Pre-Columbian Times to the Present.* New York: Frederick A. Praeger, 1969.

Disselhoff, Hans Dietrich. *Daily Life in Ancient Peru.* New York: McGraw-Hill Book Company, 1967.

Emmerich, Andre. *Art Before Columbus.* New York: Simon and Schuster, 1963.

Furst, Jill Leslie, and Furst, Peter. *Pre-Columbian Art of Mexico.* New York: Abbeville Press, 1980.

Gifford, Douglas. *Warriors, Gods and Spirits from Central and South American Mythology.* New York: Schoken Books and Douglas and McIntyre, 1983.

Kelemen, Pál. *Art of the Americas: Ancient and Hispanic.* New York: Thomas Y. Crowell Company, 1969.

Kolata, Alan L. *Valley of the Spirits.* New York: John Wiley & Sons, 1996.

Mason, J. Alden. *The Ancient Civilizations of Peru.* Baltimore: Penguin Books, Inc., 1968.

Matos Moctezuma, Eduardo. "The Great Temple," *National Geographic,* Vol. 158, No. 6, December 1980, pp. 767-775.

Mayer, Christa Charlotte. *Masterpieces of Western Textiles from The Art Institute of Chicago.* Chicago: The Art Institute of Chicago, 1969.

McDowell, Bart. "The Aztecs," *National Geographic,* Vol. 158, No. 6, December 1980, pp. 704-751.

Miller, Mary, and Taube, Karl. *The Gods and Symbols of Ancient Mexico and the Maya.* London: Thames & Hudson, Ltd., 1993.

Molina Montes, Augusto F. "Tenochtitlán's Glory," *National Geographic,* Vol. 158, No. 6, December 1980, pp. 753-765.

Museum of Modern Art, New York, in collaboration with Mexican Government. *Twenty Centuries of Mexican Art.* Mexico: Museum of Modern Art and the Instituto de Antropología e Historia de México, 1940.

Nicholson, Irene. *Mexican and Central American Mythology.* New York: The Hamlyn Publishing Group, Ltd., 1975, ©1967.

Osborne, Harold. *South American Mythology.* Feltham, Middlesex: The Hamlyn Publishing Group, Ltd., 1968.

Patent, Dorothy Hinshaw. *Quetzal, Sacred Bird of the Cloud Forest.* New York: Morrow Junior Books, 1996.

Smith, Bradley. *Mexico: A History in Art.* New York: Doubleday & Co., 1968.

Stephens, John L. *Incidents of Travel in Central America,* Chiapas and Yucatán. 1841. Reprint ed. New York: Dover Publications, 1969.

Stuart, George E. "The Timeless Vision of Teotihuacán." *National Geographic,* Vol. 188, No. 6, December 1995, pp. 2-35.

Townsend, Richard, ed. *The Ancient Americas.* Chicago: The Art Institute of Chicago, 1992.

COLONIAL PERIOD

Arciniegas, Germán. *Latin America: A Cultural History.* New York: Alfred A. Knopf, 1970.

Castedo, Leopoldo. *The Baroque Prevalence in Brazilian Art.* New York: Charles Frank Publications, Inc., 1964.

_____. *The Cuzco Circle.* New York: Center for Inter-American Relations. American Federation of Arts, 1976.

_____. *History of Latin American Art and Architecture: From Pre-Columbian Times to the Present.* New York: Frederick A. Praeger, 1969.

Díaz del Castillo, Bernal. *The Discovery and Conquest of Mexico.* Edited by Genaro García. New York: Farrar, Straus and Cudahy, 1956.

Kelemen, Pál. *Art of the Americas: Ancient and Hispanic.* New York: Thomas Y. Crowell Company, 1969.

Millones, Luis. "New Lands, Old Gods." *Américas,* Vol. 34, No. 1, January–February 1982, pp.24–30.

Museum of Modern Art, New York, in collaboration with The Mexican Government. *Twenty Centuries of Mexican Art.* Mexico: Museum of Modern Art and the Instituto de Antropología e Historia de México, 1940.

Prescott, William H. *History of the Conquest of Peru,* vols. I-II, edited by John Foster Kirk. Philadelphia: J. B. Lippincott Company, 1902.

Smith, Bradley. *Mexico: A History in Art.* New York: Doubleday & Co., 1968.

FOLK ART/ARTS AND CRAFTS

Davies, Lucy, and Fini, Mo. *Arts and Crafts of South America.* San Francisco: Chronicle Books, 1995.

Horcasitas, Fernando. "Mexican Folk Art." *National Geographic,* Vol. 153, No. 5, May 1978, pp. 649-669.

Laliberté, Norman, and Mogelon, Alex. *Collage, Montage, Assemblage.* New York: Van Nostrand Reinhold Company, 1975.

Museum of Modern Art, New York, in collaboration with Mexican Government. *Twenty Centuries of Mexican Art.* Mexico: Museum of Modern Art and the Instituto de Antropología e Historia de México, 1940.

Pieper, Jeanne. *Guatemalan Masks: The Pieper Collection.* Catalog to Exhibition, Craft and Folk Art Museum, Los Angeles, CA, 1989.

Rodman, Selden. *The Miracle of Haitian Art.* New York: Doubleday & Co., 1974.

Sayer, Chloe. *Arts and Crafts of Mexico.* San Francisco: Chronicle Books, 1990.

Schuman, Jo Miles. *Art from Many Hands: Multicultural Art Projects.* Worcester, MA: Davis Publications, Inc., 1981.

THE MODERN PERIOD

Arciniegas, Germán. *Latin America: A Cultural History.* New York: Alfred A. Knopf, 1970.

Bardi, P. M. *The Arts in Brazil.* Milan, Italy: Edizioni del Milione, 1956.

Berdecio, Roberto, and Appelbaum, Stanley, eds. *Posada's Popular Mexican Prints.* New York: Dover Publications, 1972.

Catlin, Stanton Loomis, and Grieder, Terrence. *Art of Latin America Since Independence.* Yale University and University of Texas, 1966.

Chaplik, Dorothy. *Latin American Art: An Introduction to Works of the 20th Century.* Jefferson, North Carolina: McFarland & Company, Publishers, 1989.

Chase, Gilbert. *Contemporary Art in Latin America.* New York: The Free Press, 1970.

Edwards, Emily, and Alvarez Bravo, Manuel. *Painted Walls of Mexico.* Austin, Texas: University of Texas Press, 1966.

Lucie-Smith, Edward. *Latin American Art of the 20th Century.* New York: Thames & Hudson, Ltd., 1993.

Museum of Modern Art, New York, in collaboration with Mexican Government. *Twenty Centuries of Mexican Art.* Mexico: Museum of Modern Art and the Instituto de Antropología e Historia de México, 1940.

Rasmussen, Waldo, ed. *Latin American Artists of the Twentieth Century.* New York: The Museum of Modern Art, 1993.

Rodriguez, Antonio. *A History of Mexican Mural Painting.* New York: Putnam, 1969.

INDEX

Afro-mestizos, 17
Animal deities, 27
Animal imagery, ceremonial art
 and, 84–87
Anthropomorphic, 27
Architects, astronomy and, 49
Architecture
 European structures and, 58–59
 government palaces, 58
Argentina, 5, 79, 110, 111
Arreguín, Alfredo, 108–109
Art, pre-Columbian, everyday,
 88–90
 pre-Columbian, everyday, 88–90
Astronomy
 architects and, 49
 pre-Columbian, 48–51
Atl, Dr., 63, 67
Aztec, 3, 10, 19, 26, 30, 32, 33, 79
 animal imagery, 86
 colors and, 60
 gold objects, 78
 pyramids, 40

Bermúdez, Cundo, 102, 106
Bernal, José, 112
Bolivia, 11, 13, 16, 43, 50, 73
Botero, Fernando, 106–107
Bravo, Manuel Alvarez, 65
Brazil, 15, 56, 57, 59, 65
Butler, Horacio, 5

Cabrera, Miguel, 36
Canul, Eliezer, 9, 90
Castilian Spanish, 18
Cathedral of Cuernavaca, 34
Celis, Pérez, 110–111, 112
Ceramic tile, 59
Ceremonial art, 76–87
 animal imagery, 85–87
 jewelry, 76–78
 masks, 79–80
 metalwork, 76–78

 music, dance, 82–84
Chane Arawak Indians, 79
Chavín, 3, 19, 28
 artisans, 77
 pyramids, 42
Chibchab, 3
Chile, 13, 49, 51
Chimu, 19
Christianity, Indians and, 15–16
Churches, 52-57
 Brazilian colonists and, 56
 conquest and, 52
 earthquake zones and, 52–53
 European baroque style, 55
 fortress, 53
 murals, 62
 plateresque, 54
 Portuguese influence on, 56
 roofless chapels and, 53
Clay objects, 27
 folk art, 95
Codices, 22
Cold hammering, 77
Colima, 3, 83, 89
 animal imagery, 86
Collas, 33
Colonial lifestyles, 91–94
Colors, 60
Colombia, 58, 92
Copán, 41
Copper, 76
Costa Rica, 28, 77
Cuba, 10, 65, 87, 102, 105, 111
Culton, Erin, 47, 90
Cultures
 Aztec, 3, 10, 19, 26, 30, 32, 33,
 40, 60, 78, 79, 86
 Chane Arawak Indians, 79
 Chavín, 3, 19, 28, 42, 77
 Chibchab, 3
 Chimu, 19
 Colima, 3, 83, 86, 89
 Collas, 33

Diquis, 3
Ica, 3, 19
Inca, 3, 12–13, 19, 24, 39, 78,
 83, 86
Kuna, 3, 98
Latin American, early, 6–10
Maya, 3, 6–7, 19, 30, 31, 32, 38,
 40, 41, 46, 60, 61, 86, 89
Maya Quiché Indians, 24
Mixtec, 3, 8, 19, 22
Moche, 3, 12, 19, 24, 27, 42, 79,
 82, 85
Nazca, 3, 11, 19, 24, 42
Nicoya, 3, 28
Olmec, 3, 7, 19, 28, 38, 79
Otomi, 3
Paracas, 3, 19, 71–72
Sicán, 3, 77
South American, early, 11–13
Taíno, 3, 10, 19
Tairona, 3
Teotihuacán, 8, 9, 19, 30, 40
Tiahuanaco, 19
Tiwanaku, 3, 12
Tlatilco, 3, 19, 90
Toltec, 3, 8, 19
Totonac, 3, 8
Veracruz, 3, 8, 19
Zapotec, 3, 8, 19
Cupisnique style, 11
Cuzco school, 35

Dance
 ceremonial art, 82–84
 Inca, 83
 masks, 84
Diquis, 3
Diversity, 2–5
Dominican Republic, 10, 21, 54

Ecuador, 11, 13
Esquivel, Maria Mercedes, 95
Esquivel, Renato, 18

European influences, 34–37
 missionaries, 34
 Spanish lawyers, 34

Fantasy, 110
Folk art, 95–98
 clay, 95
 paper, papier maché, 96
 skulls, skeletons, 98
 woodcarving, 96
Fonseca, Gonzalo, 110
Friedeberg, Pedro, 110

Galigo, Tony, 97
García-Ferraz, Nereida, 87
Geoglyphs, 51
Giusiano, Eduardo, 110, 111
Gold, 76
Guatemala, 8, 24, 40, 41, 73, 84,
 92, 96

Haiti, 10, 98
Hernandez, Pepe, 37
Homar, Lorenzo, 103
Homes, 46–47
 Maya, 47
Honduras, 41
Hurtado, Angel, 108

Ica, 3, 19
Inca, 3, 19, 24, 39
 animal imagery, 86
 culture, 12–13
 dance, 83
 gold objects, 78
 religious beliefs, 29
 stonework, 43–44
Indians
 Christian art and, 35
 Christianity and, 15–16
 defined, 4
 life disrupted, 15–19
Iturbide, Graciela, 107

Jaguars, 27-29
Jewelry
 ceremonial art, 76–78
Jiménez, Luis, 101

Kahlo, Frida, 107
Kukulcán, 30
Kuna, 3, 98

Lam, Widfredo, 111
Language, 18
Latin America, 2
 cultures, early, 6–10
Lazo, Agustín, 100–101
Lifestyles
 colonial life, 91–94
 folk art, 95–98
 pre-Columbian, 88–90
 today, 100-103
Linares, Miguel, 97
Lisbóa, Antonio Francisco, 56, 57
Lost-wax method, 77, 78

Marck, Edward Walhouse, 58
Marin, Augusto, 64
Marisol, 102
Masks
 ceremonial art, 79–80
 dance, 84
 pre-Columbian, 79
Materials
 clay, 27, 95
 copper, 76
 gold, 76
 linen canvases, 37
 mortar, 13
 paper, 96
 papier maché, 96
 silver, 76
 tile, 59
 wood, 96
 See also Stonework; Textiles
Mathematicians, 49
Matta, Roberto, 101
Maya, 3, 19, 21, 30, 31, 32, 38, 60,
 89
 animal imagery, 86
 astronomy, math , 49
 Corbel vaulting, 46
 culture, 6–7, 8
 homes, 47
 murals, 61
 palaces, 46, 47

stelae, 41
Maya Quiché Indians, 24
Maya-Toltec pyramid, 48
Mérida, Carlos, 104–105
Mestizo artisans, 95
Metalwork
 ceremonial art, 76-78
Mexica. See Aztec
Mexico, 6, 7, 9, 10, 16, 18, 21, 26,
 31, 33, 34, 35, 37, 47, 49, 53,
 55, 60, 61, 62, 65, 66, 78, 79,
 80, 86, 88, 90, 92, 93, 94, 96,
 97, 98, 100, 109
Milagros, 93
Missionaries, 34
Mixtec, 3, 19, 22
 culture, 8
Moche, 3, 19, 24, 27, 42, 79, 82
 animal imagery, 85
 culture, 12
 pyramids, 42
Mochica. See Moche
Modern artists, 100–103
Modern world, 104–112
 national roots, 104–107
 universal interests, 108–112
Mortar, 13
Mulatto population, 17
Murals
 conquest, after, 62–64
 Mayan, 61
 Peru, 61
 pre-Columbian, 60–61
 transition, during, 65
 twentieth century, 66–70
Murillo, Gerardo. See Atl, Dr.
Music, ceremonial art and, 82–84
Myths, legends
 Pre-Columbian, 26–33
 religious beliefs and, 27

National roots, 104–107
Nazca, 3, 19, 24, 29
 culture, 11
 pyramids, 42
Nazca Lines, 51
Nicoya, 3, 28

Observatories
 Maya, 49
 pre-Columbian, 48–51
O'Gorman, Juan, 70
O'Higgins, Pablo, 4
Olmec, 3, 19, 28, 79
 culture, 7
 pyramids, 38
Orozco, José Clemente, 67–69
Otomi, 3

Palaces, 46–47
 Maya, 47
Pampas cats, 28–29
Papier mâché, 96
Paracas, 3, 19, 71–72
Paraguay, 95
Peláez, Amelia, 105
Peru, 5, 11, 12, 13, 20, 24, 25, 27,
 29, 35, 36, 39, 42, 43, 44, 50,
 51, 54, 71, 72, 76, 77, 78, 79,
 82, 85, 87, 89, 91, 94, 95
 murals, 61
Plateresque, 54, 59
Popol Vuh, 24
Portinari, Candido, 15
Posada, José Guadalupe, 98
Pre-Columbian
 art, 20–25
 lifestyles, 88–90
 masks, 79
 murals, 60–61
 myths, legends, 26–33
 observatories, astronomy, 48–51
 palaces, homes, 46–47
 religious beliefs, 27
 textiles, 71–73
Puerto Rico, 10, 37
Pyramids, 38–44
 Aztec, 40
 Chavín, 42
 Mayan, 38–39
 Maya-Toltec, 48
 Moche, 42
 Nazca, 42
 Olmec, 38
 structure of, 39
 temple, 27

Teotihuacán, 40
Tiwanaku, 43

Quetzalcóatl, 30
Quipu, 24

Racial blending, 17
Reinoso, Diego, 24
Religious beliefs, 30–31
 Inca, 29
 influences on, 34
 jaguars, 27–29
 pampas cats, 28–29
 pre-Columbian, 27
Retablos, 93, 94
Rivera, Diego, 16, 66, 68

Sacsahuamán, 44
Santo Domingo, 52, 54
Segall, Lasar, 17
Sicán, 3, 77
Silver, 76
Siqueiros, David Alfaro, 9, 68, 69
Soriano, Juan, 103
South America
 cultures, early, 11–13
Spanish conquerors, 10, 15–19
Spanish Inquisition, 22
Stela, 8
Stonework, 38–44
 Inca, 43–44
 stelae (columns), 41
Studio Activities
 Nazca-style pottery vessel, 14
Studio activity
 collage, assemblage construc
 tion, 113
 cut-paper mola, 99
 festival of masks, 81
 Maya-style pyramid-temple,
 building, 45
 Mexican-style book making, 23
 stamping designs on fabric, 75
Szyszlo, Fernando de, 29

Taíno, 3, 19, 21
 culture, 10
Tairona, 3

Tamayo, Rufino, 80
Teotihuacán, 9, 19, 30
 culture, 8
 pyramids and, 40
Textiles
 early, 72
 handmade, today, 73
 machine made, 74
 pre-Columbian, 71–73
Tiahuanaco, 19
 See also Tiwanaku
Tile, 59
Tiwanaku, 3
 culture, 12
 pyramids, 43
Tlatilco, 3, 19, 90
Toltec, 3, 19
 culture, 8
Totonac
 culture, 3, 8

Velásquez, José Antonio, 2
Venezuela, 102, 108
Veracruz, 3, 19, 88
 culture, 8
Viracocha, 29
Votive art, 93

Woodcarving, 96

Zapotec, 3, 19
 culture, 8
Zoomorphic, 27